COLD WEATHER
CROCHET

21 cozy garments,
accessories, and
afghans to keep
you warm

MARLAINA "MARLY" BIRD

INTERWEAVE.
interweave.com

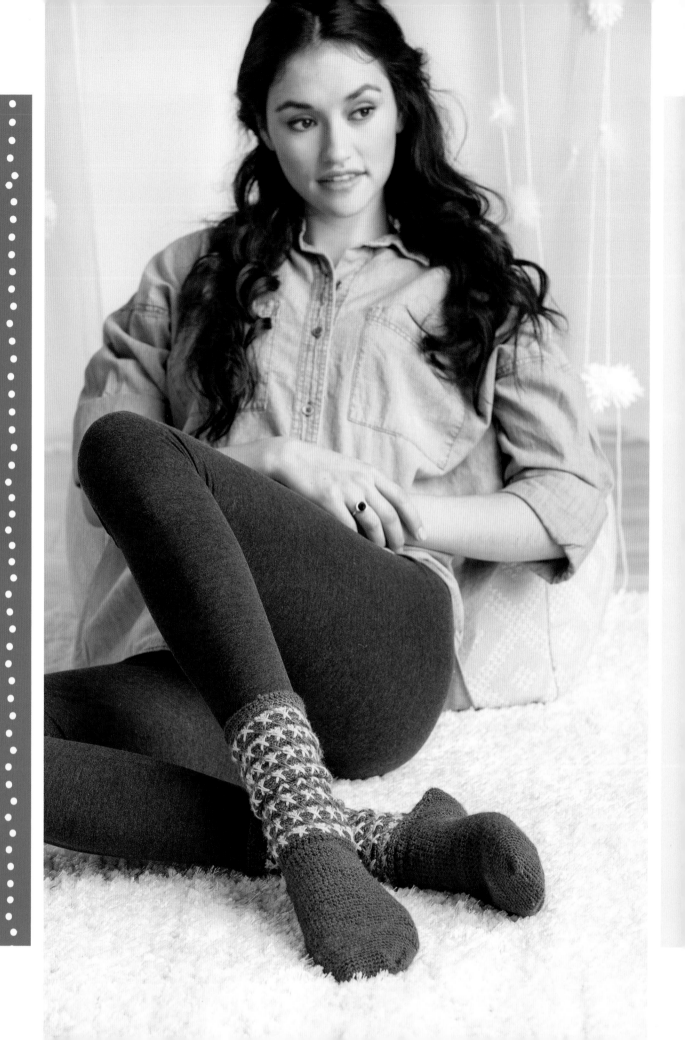

CONTENTS

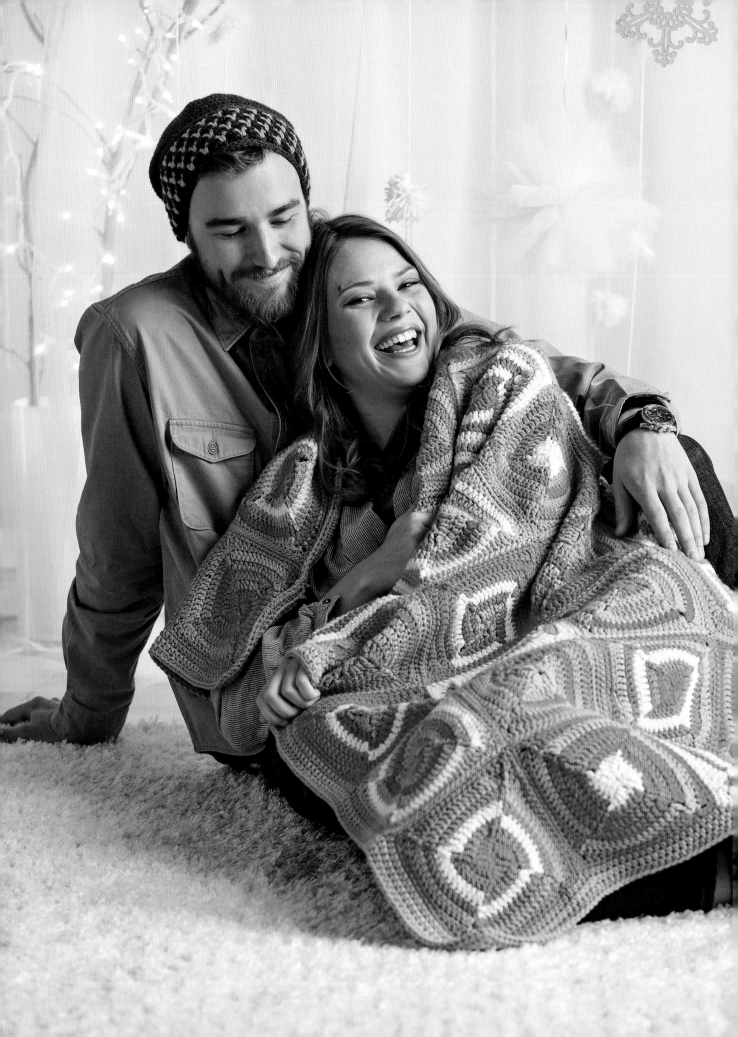

INTRODUCTION

Born and raised in Colorado, I know what cold weather means! I live in the land of layers: A place where a scarf might be fine for the morning, but later in the evening, I'm wearing a hat, scarf, mitts, and slippers while sitting fireside under an afghan!

Whether you live somewhere cold or with someone who just loves to crank the air-conditioning, my goal is to give you patterns and pieces that you know that you can crochet and enjoy! Many of the pieces seem to defy the seasons; the Lace Motif Wrap (page 106) can be worn over your favorite coat or all alone. The Hat and Chevron Cowl (page 82) are made in a durable, soft-as-silk yarn; you can throw them on as the perfect accessory in any month. Once you finish your piece, you can revel in the fact that YOU made the item that's keeping you warm!

Whether you find yourself needing to keep warm at a pee-wee football game, curling up by the fire with your honey, or camping in the freezing cold, you can count on the fact that these pieces will keep you cozy.

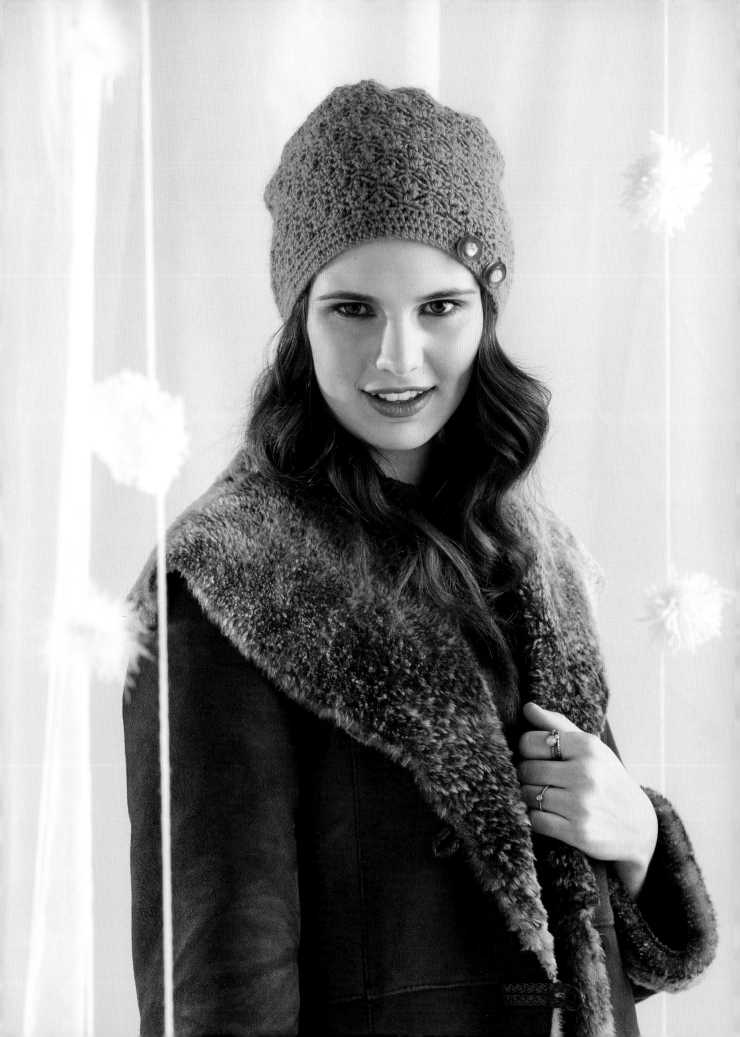

PEWTER
SLOUCHY HAT

Crocheted from the bottom up, this simple slouchy hat uses a delicate lace pattern that, when coupled with the soft angora- and merino-blend yarn, makes a beautiful haloed fabric perfect for the brisk winter breeze. Add a touch of whimsy with unique resin buttons on the brim.

FINISHED MEASUREMENTS
19 (20, 23)" (48.5 [51, 58.5] cm) in circumference and 9" (23 cm) tall.
Directions are given for size Small. Directions for Medium and Large are in parentheses.

YARN
Sportweight (#3 Light).
Shown here: Lion Brand Collection Angora Merino (80% extrafine merino wool, 20% angora, 131 yd [120 m]/1¾ oz [50 g]): #152 Pewter, 2 balls.

HOOK
Size G-6/4mm hook. *Adjust hook size if necessary to obtain the correct gauge.*

NOTIONS
Yarn needle; 2 decorative buttons; sewing needle; matching sewing thread.

GAUGE
19 sts = 4" (10 cm); 6 rows in body pattern = 4" (10 cm).

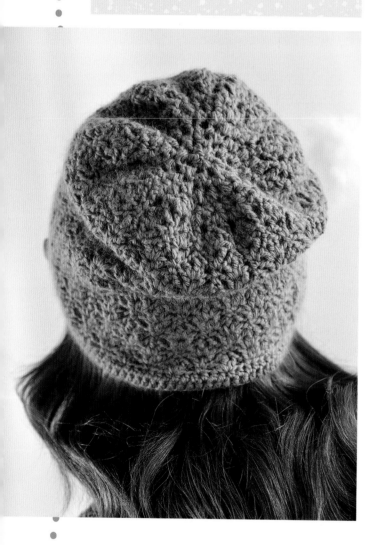

NOTE

❋ The yarn has a lot of give, so you want to have a little negative ease around the band. If you have the negative ease, the lace really opens up.

HAT

BRIM

Ch 90 (96, 108); without twisting ch, join with a sl st in the first ch to form a ring, turn.

Rnd 1: Ch 1, sc in each ch around, join with a sl st in the first sc—90 (96, 108) sc.

Rnds 2 and 3: Ch 1, sc in each sc around, join with a sl st in the first sc.

BODY

Rnd 1: Ch 4 (counts as dc, ch 1 here and throughout), (tr, ch 1, dc) in same st, *ch 1, sk the next 2 sc, sc in the next sc, ch 1, sk the next 2 sc**, (dc, ch 1, tr, ch 1, dc) in the next sc; rep from * around, ending the last rep at **, join with a sl st in the 3rd ch of the beg ch-4—15 (17, 18) reps.

Rnd 2: Ch 1, sc in the first tr, *ch 1, tr in the next sc, ch 1, dc in the 2 strands of the lower side of tr just made, ch 1**, sc in the next tr; rep from * around, ending the last rep at **, join with a sl st in the first sc.

Rnd 3: Ch 1, sc in the first sc, *ch 1, sk the next ch-1 sp, (dc, ch 1, tr, ch 1, dc) in the next ch-1 sp, ch 1**, sk the next sp, sc in the next sc; rep from * around, ending the last rep at **, join with a sl st in the first sc.

Rnd 4: Ch 5 (counts as tr, ch 1), dc in the 4th ch from the hook, *ch 1, sk the next 2 ch-1 sps, sc in the next tr, ch 1**, tr in the next sc, ch 1, dc in the 2 strands of the lower side of the tr just made; rep from * around, ending the last rep at **, join with a sl st in the 3rd ch and 4th ch of the beg ch-4 sp.

Rnd 5: Ch 4, (tr, ch 1, dc) in same st, *ch 1, sk the next ch-1 sp, sc in the next sc, ch 1, sk the next ch-1 sp**, (dc, ch 1, tr, ch 1, dc) in the next ch-1 sp; rep from * across, ending the last rep at **, join with a sl st in 3rd ch and 4th ch of beg ch-4.

Rnds 6–13: Rep Rnds 2–5 twice.

CROWN

Rnd 1: Ch 1, *sc in the next tr, ch 2, dc in the next sc, ch 2; rep from * around, join with sl st in first sc—30 (34, 36) ch-2 sps.

Rnd 2: Ch 1, sc in first sc, *ch 1, dc2tog over the next 2 ch-2 sps, ch 1**, sc in the next sc; rep from * around, ending the last rep at **, join with a sl st in first sc, sl st in the next ch-1 sp—30 (34, 36) ch-2 sps.

Rnd 3: Ch 1, *sc in the next dc2tog, sc2tog over the next 2 ch-1 sps; rep from * around, join with a sl st into sc and the next ch-1 sp—30 (34, 36) sts.

Rnds 4 and 5: Ch 2 (counts as half of the dc2tog), dc in the next st, *dc2tog over the next 2 sts; rep from * around, join with a sl st in first dc—15 (17, 18) sts. Fasten off, leaving a sewing length.

FINISHING

Using a yarn needle, weave sewing length through the loops of the remaining stitches, then pull snug to close the hole at the top of the crown. Thread the needle to the inside of the hat and then weave in ends.

Using sewing needle and thread, sew buttons to single crochet band 1½" (3.8 cm) apart as pictured.

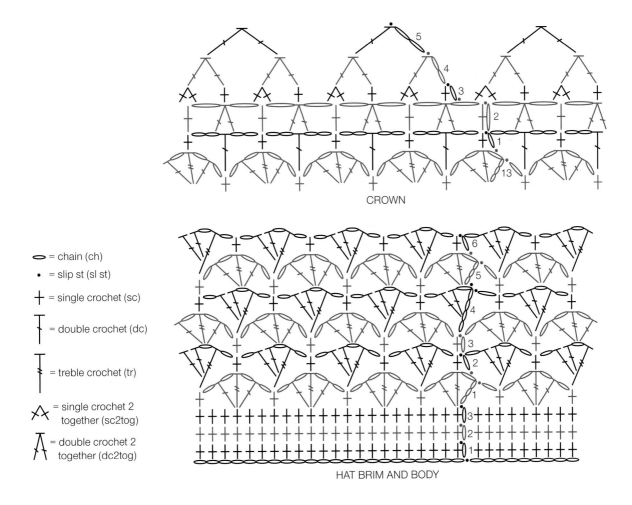

○ = chain (ch)

• = slip st (sl st)

+ = single crochet (sc)

⊤ = double crochet (dc)

⊤ = treble crochet (tr)

⋏ = single crochet 2 together (sc2tog)

Ⓐ = double crochet 2 together (dc2tog)

CROWN

HAT BRIM AND BODY

CABLED SHAWL

The way this yarn is made results in a wonderful bounce that really makes the crochet cables three-dimensional. Striped shawls are visually appealing but adding solid-colored cables to the majority of the body makes a perfect combination.

FINISHED MEASUREMENTS
About 35" (89 cm) across the top and 70" (178 cm) across the bottom after blocking.

YARN
Sportweight (#2 Fine).

Shown here: Drew Emborsky Gemstones (90% merino wool, 10% nylon, 440 yd [402 m]/4 oz [113 g]): Peridot (A), 4 hanks; Diamond (B), 1 hank.

HOOK
Size D-3 (3.25 mm) hook. *Adjust hook size if necessary to obtain the correct gauge.*

NOTIONS
Stitch markers; yarn needle.

GAUGE
20 sts and 14 rows = 4" (10 cm) in double crochet after blocking.

NOTE

* The shawl is worked from the bottom up.
 Skip the stitch behind each post stitch made.

STITCH GUIDE

Front Post treble crochet (FPtr): Yo (twice), insert hook from front to back to front again around the post of the the next st, yo, draw yarn through st, [yo, draw yarn through 2 loops on hook] 3 times.

Back Post treble crochet (BPtr): Yo, insert hook from back to front to back again around the post of the the next st, yo, draw yarn through st, [yo, draw yarn through 2 loops on hook] 3 times.

C6R: Skip the the next 3 sts, FPtr around the post of the next 3 sts; working behind 3 post sts just made, FPtr around the post of each of last 3 skipped sts.

C6L: Skip the the next 3 sts, FPtr around the post of the the next 3 sts; working in front of 3 post sts just made, FPtr around the post of each of the last 3 skipped sts.

C4R: Skip the next st, FPtr around the post of the the next 3 sts; working behind 3 post sts just made, tr in last skipped st.

C4L: Skip the next 3 sts, tr in the next st, working in front of 3 post sts just made; FPtr around the post of each of last 3 skipped sts.

C6R-2: Skip the next 3 sts, FPtr around the post of the next 3 sts, working behind 3 post sts just made; tr in each of the last 3 skipped sts.

C6L-2: Skip the the next 3 sts, tr in each of the the next 3 sts, working in front of the last 3 sts made; FPtr around the post of each of the last 3 skipped sts.

Double crochet 2 together (dc2tog): [Yo, insert hook in the the next st, yo, draw yarn through st, yo, draw yarn through 2 loops on hook] twice, yo, draw the yarn through 3 loops on hook.

Reverse single crochet (reverse sc): Working from left to right, insert the hook into the the next st to the right, yo, draw yarn through st, yo, draw the yarn through 2 loops on hook.

SHAWL

With B, ch 436.

Row 1: Dc in 3rd ch from hook and in each ch across changing to A in last st, turn—434 dc.

Note: If you place a marker every 62 stitches, the shawl will be divided into 7 panels.

Row 2: (RS) Ch 2 (does not count as a st here and throughout), starting in first st, *dc in each of the the next 24 sts, C6R, dc in each of the the next 2 sts, C6L, dc in each of the the next 24 sts; rep from * across, turn—7 C6R; 7 C6L; 7 diamond patterns begun.

Row 3: (WS) Ch 2, *dc in each of the next 24 sts, BPtr around the post of each of the next 6 sts, dc in each of the next 2 sts, BPtr around the post of each of the next 6 sts, dc in each of the next 24 sts; rep from * across, turn.

Row 4: Ch 2, *dc in each of the next 23 sts, C4R, C4L, C4R, C4L, dc in each of the next 23 sts; rep from * across, turn.

Row 5: (WS) Ch 2, *dc in each of the next 23 sts, BPtr around the post of each of the next 3 sts, dc in each of the next 2 sts, BPtr around the post of each of the next 6 sts, dc in each of the next 2 sts, BPtr around the post of each of the next 3 sts, dc in each of the next 23 sts; rep from * across, turn.

Row 6: Ch 2, *dc in each of the next 22 sts, C4R, dc in each of the next 2 sts, C6R, dc in each of the next 2 sts, C4L, dc in each of the next 22 sts; rep from * across, turn.

Row 7: Ch 2, *dc in each of the next 22 sts, BPtr around the post of each of the next 3 sts, dc in each of the next 3 sts, BPtr around the post of each of the next 6 sts, dc in each of the next 3 sts, BPtr around the post of each of the next 3 sts, dc in each of the next 22 sts; rep from * across, turn.

Row 8 (dec row): Ch 2, *dc in each of the next 2 sts, dc2og over the next 2 sts, dc in each of the next 17 sts, C4R, dc in each of the next 2 sts, C4R, C4L, dc in each of the next 2 sts, C4L, dc in each of the next 17 sts, dc2tog over the next 2 sts, dc in each of the next 2 sts; rep from * across, turn—420 sts.

Row 9: Ch 2, *dc in each of the next 20 sts, BPtr around the post of each of the next 3 sts, 3 dc, BPtr around the post of each of the next 3 sts, dc in each of the next 2 sts, BPtr around the post of each of the next 3 sts, 3 dc, BPtr around the post of each of the next 3 sts, dc in each of the next 20 sts; rep from * across, turn.

Row 10: Ch 2, *dc in each of the next 17 sts, C6R-2, dc in each of the next 2 sts, C4R, dc in each of the next 2 sts, C4L, dc in each of the next 2 sts, C6L-2, dc in each of the next 17 sts; rep from * across, turn.

Row 11: Ch 2, *dc in each of the next 17 sts, BPtr around the post of each of the next 3 sts, dc in

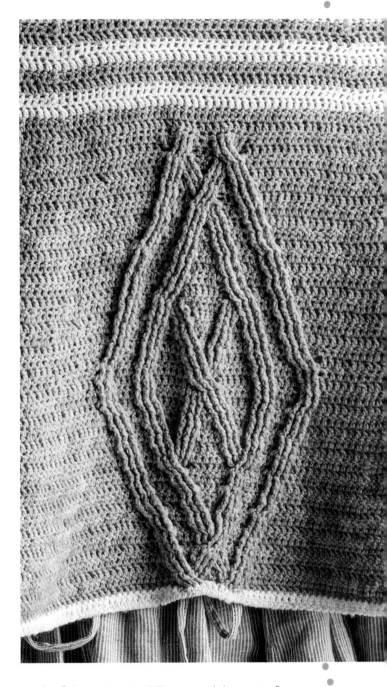

each of the next 5 sts, BPtr around the post of each of the next 3 sts, dc in each of the next 4 sts, BPtr around the post of each of the next 3 sts, dc in each of the next 5 sts, 3 BPtr, dc in each of the next 17 sts; rep from * across, turn.

Row 12: Ch 2, *dc in each of the next 6 sts, C4R, dc in each of the next 4 sts, C4R, dc in each of the next 4 sts, C4L, dc in each of the next 4 sts, C4L, dc in each of the next 16 sts; rep from * across, turn.

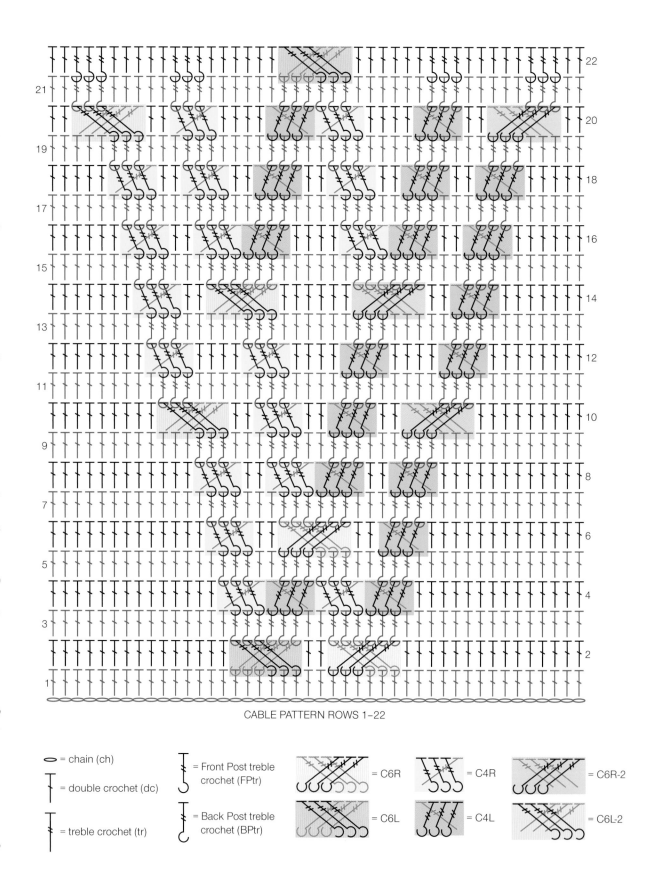

CABLE PATTERN ROWS 1–22

\bigcirc = chain (ch)

\top = double crochet (dc)

\intercal = treble crochet (tr)

\int = Front Post treble crochet (FPtr)

\int = Back Post treble crochet (BPtr)

= C6R

= C4R

= C6R-2

= C6L

= C4L

= C6L-2

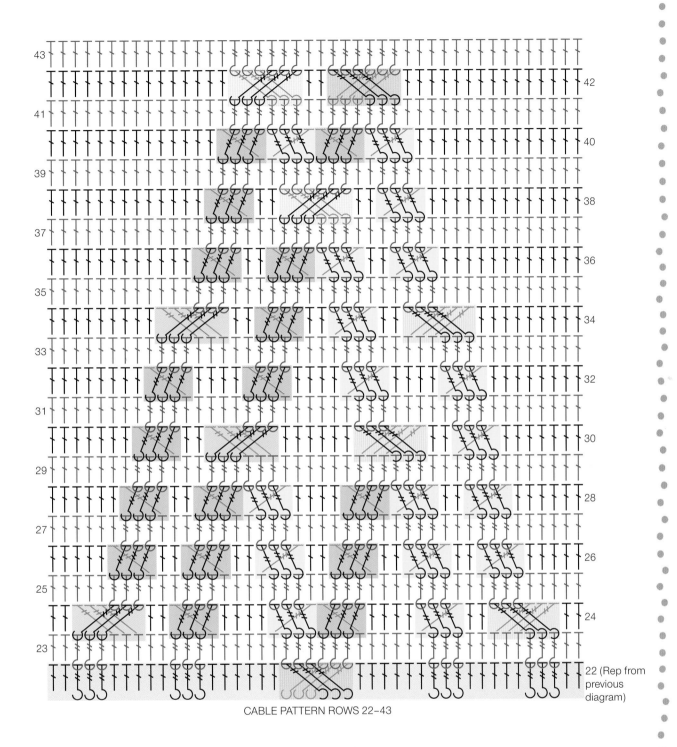

CABLE PATTERN ROWS 22–43

Row 13: Ch 2, *dc in each of the next 6 sts, BPtr around the post of each of the next 3 sts, dc in each of the next 5 sts, BPtr around the post of each of the next 3 sts, dc in each of the next 6 sts, BPtr around the post of each of the next 3 sts, dc in each of the next 5 sts, BPtr around the post of each of the next 3 sts, dc in each of the next 16 sts; rep from * across, turn.

Row 14: Ch 2, *dc in each of the next 5 sts, C4R, dc in each of the next 2 sts, C6R, dc in each of the next 6 sts, C6L, dc in each of the next 2 sts, C4L, dc in each of the next 15 sts; rep from * across, turn.

Row 15 (dec row): Ch 2, *dc in each of the next 2 sts, dc2tog over the next 2 sts, dc in each of the next 11 sts, BPtr around the post of each of the next 3 sts, dc in each of the next 3 sts, BPtr around the post of each of the next 6 sts, dc in each of the next 6 sts, BPtr around the post of each of the next 6 sts, dc in each of the next 3 sts, BPtr around the post of each of the next 3 sts, dc in each of the next 11 sts, dc2tog over the next 2 sts, dc in each of the next 2 sts; rep from * across, turn—406 sts.

Row 16: Ch 2, *dc in each of the next 3 sts, C4R, dc in each of the next 2 sts, C4R, C4L, dc in each of the next 4 sts, C4R, C4L, dc in each of the next 2 sts, C4L, dc in each of the next 3 sts; rep from * across, turn.

Row 17: Ch 2, *dc in each of the next 3 sts, BPtr around the post of each of the next 3 sts, dc in each of the next 3 sts, BPtr around the post of each of the next 3 sts, dc in each of the next 2 sts, BPtr around the post of each of the next 3 sts, dc in each of the next 4 sts, BPtr around the post of each of the next 3 sts, dc in each of the next 2 sts, BPtr around the post of each of the next 3 sts, dc in each of the next 3 sts, BPtr around the post of each of the next 3 sts, dc in each of the next 3 sts; rep from * across, turn.

Row 18: Ch 2, *dc in each of the next 2 sts, C4R, dc in each of the next 2 sts, C4R, dc in each of the next 2 sts, C4L, dc in each of the next 2 sts, C4R, dc in each of the next 2 sts, C4L, dc in each of the next 2 sts, C4L, dc in each of the next 2 sts; rep from * across, turn.

Row 19: Ch 2, *dc in each of the next 2 sts, BPtr around the post of each of the next 3 sts, dc in each of the next 3 sts, BPtr around the post of each of the next 3 sts, dc in each of the next 4 sts, BPtr around the post of each of the next 3 sts, dc in each of the next 2 sts, BPtr around the post of each of the next 3 sts, dc in each of the next 4 sts,

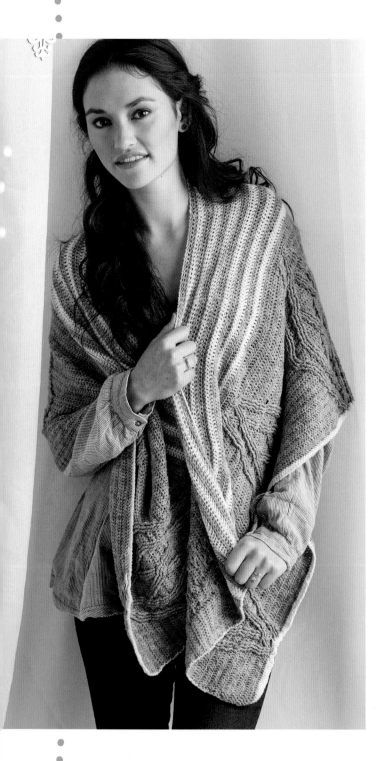

BPtr around the post of each of the next 3 sts, dc in each of the next 3 sts, BPtr around the post of each of the next 3 sts, dc in each of the next 2 sts; rep from * across, turn.

Row 20: Ch 2, *dc in each of the next 9 sts, C6R-2, dc in each of the next 2 sts, C4R, dc in each of the next 4 sts, C4L, C4R, dc in each of the next 4 sts, C4L, dc in each of the next 2 sts, C6L-2, dc in each of the next 9 sts; rep from * across, turn.

Row 21: Ch 2, *dc in each of the next 9 sts, BPtr around the post of each of the next 3 sts, dc in each of the next 5 sts, BPtr around the post of each of the next 3 sts, dc in each of the next 6 sts, BPtr around the post of each of the next 6 sts, dc in each of the next 6 sts, BPtr around the post of each of the next 3 sts, dc in each of the next 5 sts, BPtr around the post of each of the next 3 sts, dc in each of the next 9 sts; rep from * across, turn.

Row 22 (dec row): Ch 2, *dc in each of the next 2 sts, dc2tog over the next 2 sts, dc in each of the next 5 sts, 3 fptc, dc in each of the next 5 sts, 3 fptc, dc in each of the next 6 sts, c6l, dc in each of the next 6 sts, 3 fptc, dc in each of the next 5 sts, 3 fptc, dc in each of the next 5 sts, dc2tog over the next 2 sts, dc in each of the next 2 sts; rep from * across, turn—392 sts.

Row 23: Ch 2, *dc in each of the next 8 sts, BPtr around the post of each of the next 3 sts, dc in each of the next 5 sts, BPtr around the post of each of the next 3 sts, dc in each of the next 6 sts, BPtr around the post of each of the next 6 sts, dc in each of the next 6 sts, BPtr around the post of each of the next 3 sts, dc in each of the next 5 sts, BPtr around the post of each of the next 3 sts, dc in each of the next 8 sts; rep from * across, turn.

Row 24: Ch 2, *dc in each of the next 8 sts, C6L-2, dc in each of the next 2 sts, C4L, dc in each of the next 4 sts, C4R, C4L, dc in each of the next 4 sts, C4R, dc in each of the next 2 sts, C6R-2, dc in each of the next 8 sts; rep from * across, turn.

Row 25: Ch 2, *dc in each of the next 11 sts, BPtr around the post of each of the next 3 sts, dc in each of the next 3 sts, BPtr around the post of each of the next 3 sts, dc in each of the next 4 sts, BPtr around the post of each of the next 3 sts, dc

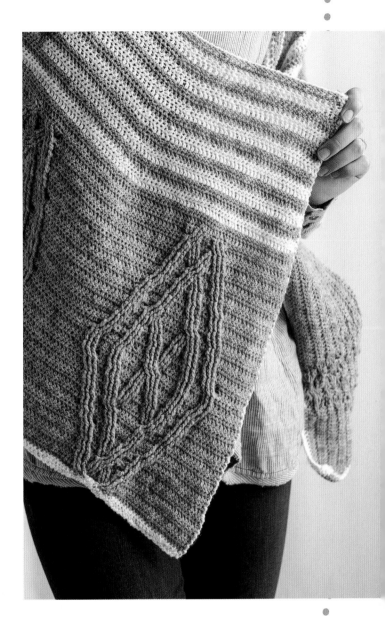

in each of the next 2 sts, BPtr around the post of each of the next 3 sts, dc in each of the next 4 sts, BPtr around the post of each of the next 3 sts, dc in each of the next 3 sts, BPtr around the post of each of the next 3 sts, dc in each of the next 11 sts; rep from * across, turn.

Row 26: Ch 2, *dc in each of the next 11 sts, C4L, dc in each of the next 2 sts, C4L, dc in each of the next 2 sts, C4R, dc in each of the next 2 sts, C4L, dc in each of the next 2 sts, C4R, dc in each of the next 2 sts, C4R, dc in each of the next 11 sts; rep from * across, turn.

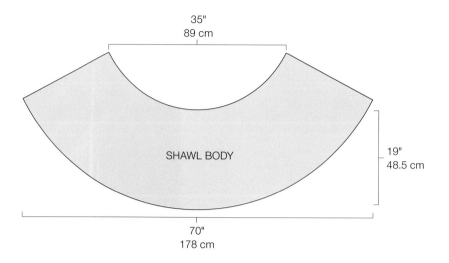

35"
89 cm

SHAWL BODY

19"
48.5 cm

70"
178 cm

Row 27: Ch 2, *dc in each of the next 2 sts, BPtr around the post of each of the next 3 sts, dc in each of the next 3 sts, BPtr around the post of each of the next 3 sts, dc in each of the next 2 sts, BPtr around the post of each of the next 3 sts, dc in each of the next 4 sts, BPtr around the post of each of the next 3 sts, dc in each of the next 2 sts, BPtr around the post of each of the next 3 sts, dc in each of the next 3 sts, BPtr around the post of each of the next 3 sts, dc in each of the next 2 sts; rep from * across, turn.

Row 28: Ch 2, *dc in each of the next 2 sts, C4L, dc in each of the next 2 sts, C4L, C4R, dc in each of the next 4 sts, C4L, C4R, dc in each of the next 2 sts, C4R, dc in each of the next 2 sts; rep from * across, turn.

Row 29 (dec row): Ch 2, *dc in each of the next 2 sts, dc2tog over the next 2 sts, dc in each of the next 9 sts, BPtr around the post of each of the next 3 sts, dc in each of the next 3 sts, BPtr around the post of each of the next 6 sts, dc in each of the next 6 sts, BPtr around the post of each of the next 6 sts, dc in each of the next 3 sts, BPtr around the post of each of the next 3 sts, dc in each of the next 9 sts, dc2tog over the next 2 sts, dc in each of the next 2 sts; rep from * across, turn—378 sts.

Row 30: Ch 2, *dc in each of the next 2 sts, C4L, dc in each of the next 2 sts, C6L-2, dc in each of the next 6 sts, C6R-2, dc in each of the next 2 sts, C4R, dc in each of the next 2 sts; rep from * across, turn.

Row 31: Ch 2, *dc in each of the next 3 sts, BPtr around the post of each of the next 3 sts, dc in each of the next 5 sts, BPtr around the post of each of the next 3 sts, dc in each of the next 6 sts, BPtr around the post of each of the next 3 sts, dc in each of the next 5 sts, BPtr around the post of each of the next 3 sts, dc in each of the next 3 sts; rep from * across, turn.

Row 32: Ch 2, *dc in each of the next 3 sts, C4L, dc in each of the next 4 sts, C4L, dc in each of the next 4 sts, C4R, dc in each of the next 4 sts, C4R, dc in each of the next 3 sts; rep from * across, turn.

Row 33: Ch 2, *dc in each of the next 4 sts, BPtr around the post of each of the next 3 sts, dc in each of the next 5 sts, BPtr around the post of each of the next 3 sts, dc in each of the next 4 sts, BPtr around the post of each of the next 3 sts, dc in each of the next 5 sts, BPtr around the post of each of the next 3 sts, dc in each of the next 14 sts; rep from * across, turn.

Row 34: Ch 2, *1dc in each of the next 4 sts, C6L-2, dc in each of the next 2 sts, C4L, dc in each of the next 2 sts, C4R, dc in each of the next 2 sts, C6R-2, dc in each of the next 14 sts; rep from * across, turn.

Row 35: Ch 2, *dc in each of the next 17 sts, BPtr around the post of each of the next 3 sts, dc in each of the next 3 sts, BPtr around the post of each of the next 3 sts, dc in each of the next 2 sts, BPtr around the post of each of the next 3 sts, dc in each of the next 3 sts, BPtr around the post

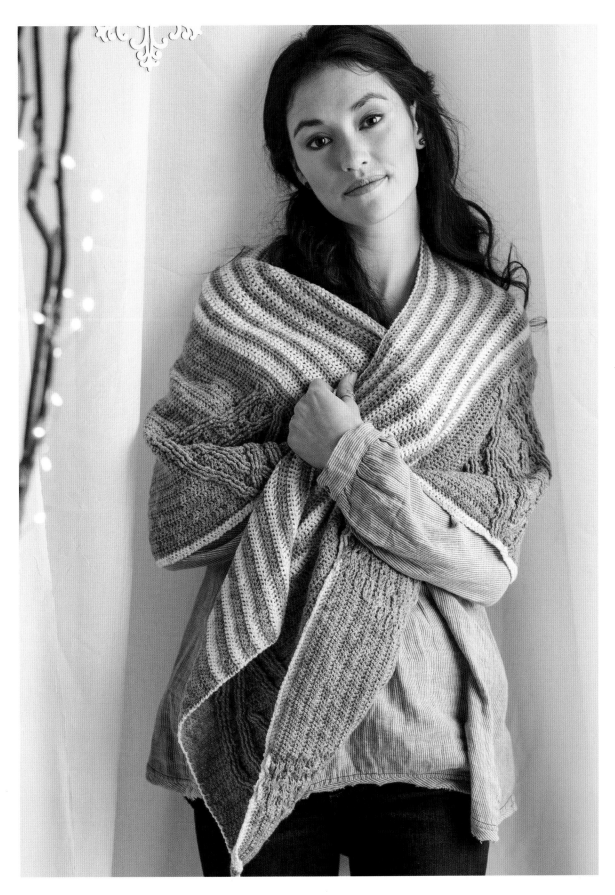

of each of the next 3 sts, dc in each of the next 17 sts; rep from * across, turn.

Row 36 (dec row): Ch 2, *dc in each of the next 2 sts, dc2tog over the next 2 sts, dc in each of the next 3 sts, C4L, dc in each of the next 2 sts, C4L, C4R, dc in each of the next 2 sts, C4R, dc in each of the next 3 sts, dc2tog over the next 2 sts, dc in each of the next 2 sts; rep from * across, turn—364 sts.

Row 37: Ch 2, *dc in each of the next 17 sts, BPtr around the post of each of the next 3 sts, dc in each of the next 3 sts, BPtr around the post of each of the next 6 sts, dc in each of the next 3 sts, BPtr around the post of each of the next 3 sts, dc in each of the next 17 sts; rep from * across, turn.

Row 38: Ch 2, *dc in each of the next 17 sts, C4L, dc in each of the next 2 sts, C6R, dc in each of the next 2 sts, C4R, dc in each of the next 17 sts; rep from * across, turn.

Row 39: Ch 2, *dc in each of the next 18 sts, BPtr around the post of each of the next 3 sts, dc in each of the next 2 sts, BPtr around the post of each of the next 6 sts, dc in each of the next 2 sts, BPtr around the post of each of the next 3 sts, dc in each of the next 18 sts; rep from * across, turn.

Row 40: Ch 2, *dc in each of the next 18 sts, C4L, C4R, C4L, C4R, dc in each of the next 18 sts; rep from * across, turn.

Row 41: Ch 2, *dc in each of the next 9 sts, BPtr around the post of each of the next 6 sts, dc in each of the next 2 sts, BPtr around the post of each of the next 6 sts, dc in each of the next 9 sts; rep from * across, turn.

Row 42: Ch 2, *dc in each of the next 9 sts, C6L, dc in each of the next 2 sts, C6R, dc in each of the next 9 sts; rep from * across, turn.

Row 43 (dec row): Ch 2, *dc in each of the next 2 sts, dc2tog over the next 2 sts, dc in each of the next 4 sts, BPtr around the post of each of the next 6 sts, dc in each of the next 2 sts, BPtr around the post of each of the next 6 sts, dc in each of the next 4 sts, dc2tog over the next 2 sts, dc in each of the next 2 sts; rep from * across, turn—350 sts.

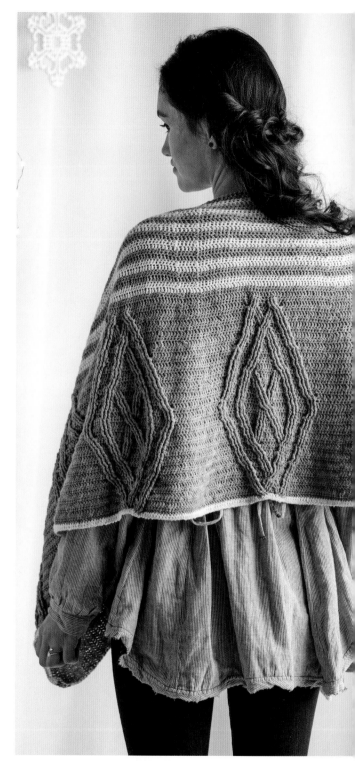

STRIPED PATTERN

*Note: Work in the following color sequence: *2 rows A; 2 rows B; rep from * throughout.*

Row 1 and all odd-numbered rows: Ch 2, dc in each st across, turn.

Row 2 (dec row): Ch 2, *dc in each of the next 2 sts, dc2tog over the next 2 sts, dc in each of the next 42 sts, dc2tog over the next 2 sts, dc in each of the next 2 sts; rep from * across changing to B in last st, turn—336 sts.

Row 4 (dec row): Ch 2, *dc in each of the next 2 sts, dc2tog over the next 2 sts, dc in each of the next 4 sts, dc2tog over the next 2 sts, dc in each of the next 2 sts; rep from * across changing to A in last st, turn—322 sts.

Continue to work in color sequence as established.

Row 6 (dec row): Ch 2, *dc in each of the next 2 sts, dc2tog over the next 2 sts, dc in each of the next 38 sts, dc2tog over the next 2 sts, dc in each of the next 2 sts; rep from * across, turn—308 sts.

Row 8 (dec row): Ch 2, *dc in each of the next 2 sts, dc2tog over the next 2 sts, dc in each of the next 36 sts, dc2tog over the next 2 sts, dc in each of the next 2 sts; rep from * across, turn—294 sts.

Row 10 (dec row): Ch 2, *dc in each of the next 2 sts, dc2tog over the next 2 sts, dc in each of the next 34 sts, dc2tog over the next 2 sts, dc in each of the next 2 sts; rep from * across, turn—280 sts.

Row 12 (dec row): Ch 2, *dc in each of the next 2 sts, dc2tog over the next 2 sts, 3dc in each of the next 2 sts, dc2tog over the next 2 sts, dc in each of the next 2 sts; rep from * across, turn—266 sts.

Row 14 (dec row): Ch 2, *dc in each of the next 2 sts, dc2tog over the next 2 sts, 30 dc, dc2tog over the next 2 sts, dc in each of the next 2 sts; rep from * across, turn—252 sts.

Row 16 (dec row): Ch 2, *dc in each of the next 2 sts, dc2tog over the next 2 sts, 28 dc, dc2tog over the next 2 sts, dc in each of the next 2 sts; rep from * across, turn—238 sts.

Row 18 (dec row): Ch 2, *dc in each of the next 2 sts, dc2tog over the next 2 sts, 2dc in each of the next 6 sts, dc2tog over the next 2 sts, dc in each of the next 2 sts; rep from * across, turn—224 sts.

Row 20 (dec row): Ch 2, *dc in each of the next 2 sts, dc2tog over the next 2 sts, 2dc in each of the next 4 sts, dc2tog over the next 2 sts, dc in each of the next 2 sts; rep from * across, turn—210 sts.

Row 22 (dec row): Ch 2, *dc in each of the next 2 sts, dc2tog over the next 2 sts, 2dc in each of the next 2 sts, dc2tog over the next 2 sts, dc in each of the next 2 sts; rep from * across, turn—196 sts.

Row 24 (dec row): Ch 2, *dc in each of the next 2 sts, dc2tog over the next 2 sts, 20 dc, dc2tog over the next 2 sts, dc in each of the next 2 sts; rep from * across, turn—164 sts.

Row 26 (dec row): Ch 2, *dc in each of the next 2 sts, dc2tog over the next 2 sts, dc in each of the next 18 sts, dc2tog over the next 2 sts, dc in each of the next 2 sts; rep from * across, turn—182 sts. Fasten off.

TRIM

With RS facing, join B with a sl st in the top right-hand corner of the shawl, ch 1; working from left to right, reverse sc evenly around the shawl, join with a sl st in the first reverse sc. Fasten off.

Weave in the ends.

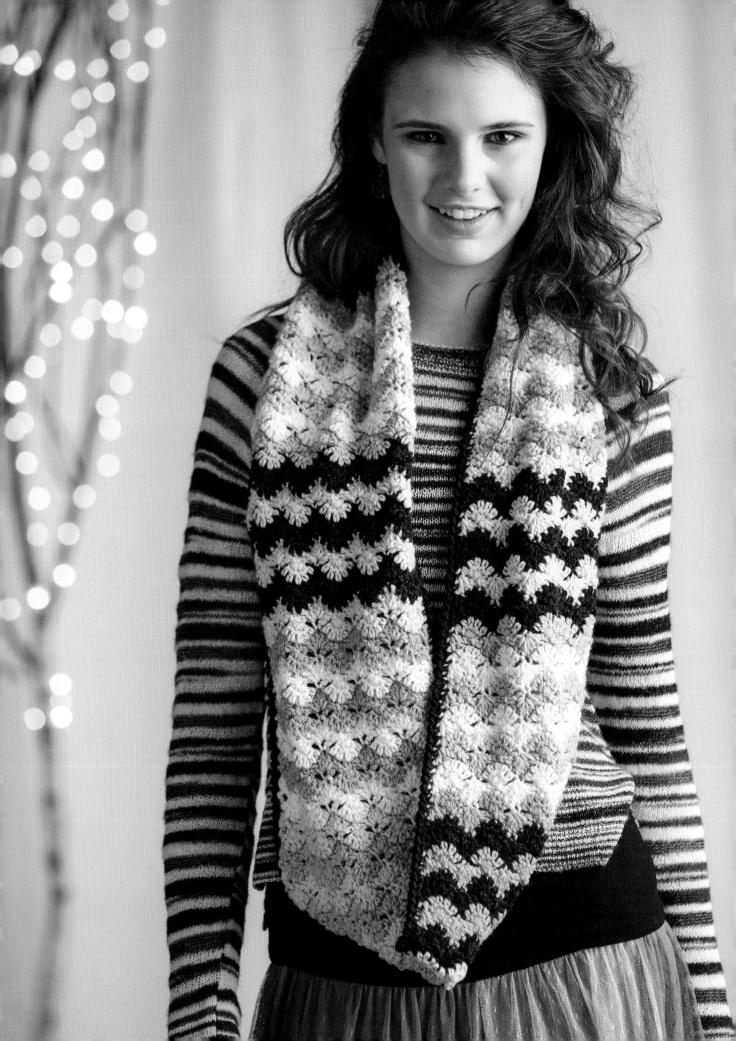

PRETTY IN PINK
INFINITY COWL

Mix and match shades of pink, white, and dark brown, and you get a piece that really knocks your socks off! The stitch pattern used creates a lovely chevron look without being actual chevrons. Wear this long or wrapped around your neck a few times—either way, it will be a staple in your wardrobe.

FINISHED MEASUREMENTS
10" (25.5 cm) wide and 56" (142 cm) in circumference after blocking.

YARN
Worsted weight (#4 Medium).

Shown here: Cascade 220 Superwash (100% superwash wool, 220 yd [201 m]/3½ oz [100 g]): #894 Strawberry Cream (A), #875 Feather Grey (B), #910a Winter White (C), #901 Cotton Candy (D), and #1913 Jet (E), 1 skein each.

HOOK
Size J-10/5.5mm hook. *Adjust hook size if necessary to obtain the correct gauge.*

NOTIONS
Yarn needle.

GAUGE
2 pattern reps = 3" (7.5 cm); 8 rows in pattern = 3¾" (9.5 cm) after blocking.

NOTES

* Change the colors on the last stitch of each RS row. When working in a two-color segment of the color sequence, carry the colors up along the side of the Cowl. When switching to a new color segment, cut the first color, leaving a 4" (10 cm) tail to weave in after changing the color.

STITCH GUIDE

Double crochet 5 together (dc5tog): [Yo, insert hook in the next st, yo, draw up a loop, yo, draw through 2 loops on hook] 5 times, yo, draw through 6 loops on hook.

Reverse single crochet (reverse sc): Working from left to right, insert the hook in the next st to the right, yo, draw up a loop, yo, draw the yarn through the 2 loops on hook.

COWL

With A, ch 51.

Row 1: (RS) 2 dc in 3rd ch from hook (beg ch-2 counts as dc), sk the next 3 ch sp, sc in the next ch, *sk the next 3 ch sp, 5 dc in the next ch, sk the next 3 ch sp, sc in the next ch; rep from * across to the last 4 chs, sk the next 3 ch sp, 3 dc in the last ch, complete the last st with B, turn—five 5-dc shells; 2 half shells.

COLOR SEQUENCE

Work in the following color sequence:

Two rows each of *B, A, B, A, B, C, D, C, D, C, D, A, E, A, E, A, E, B, C, B, C, B, C, D, E, D, E, D, E*, A; rep from * to * once.

Row 2: With the next color, ch 1, sc in the first dc, ch 3, dc5tog over the next 5 sts, ch 3, *sc in the next dc, ch 3, dc5tog over the next 5 sts, ch 3; rep from * across, sc in the top of the tch, turn—6 dc5tog.

Row 3: (RS) Ch 2 (counts as dc here and throughout), 2 dc in the first st, sc in the next dc5tog,* 5 dc in the next sc, sc in the next dc5tog; rep from *

across, 3 dc in the last sc, changing to the next color in the last st, turn.

Rows 4–119: Maintaining the color sequence as established, rep Rows 2–3.

Row 120: Rep Row 2. Fasten off, leaving a long sewing length of yarn.

FINISHING

Matching sts and using a long sewing length of yarn, sew the last row to the foundation ch.

EDGING

Rnd 1: With the RS facing, join E with a sl st on one side of the edge of the Cowl at the seam, ch 1, sc evenly around the Cowl's long edge, join with a sl st in the first sc, do not turn.

Rnd 2: Ch 1, working from left to right, reverse sc in each sc around, join with a sl st in the first reverse sc.

Rep the Edging on the other side edge. Fasten off.

Weave in the ends.

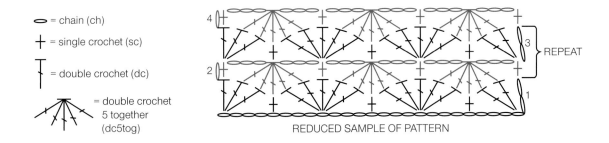

○ = chain (ch)

+ = single crochet (sc)

⊤ = double crochet (dc)

= double crochet 5 together (dc5tog)

REPEAT

REDUCED SAMPLE OF PATTERN

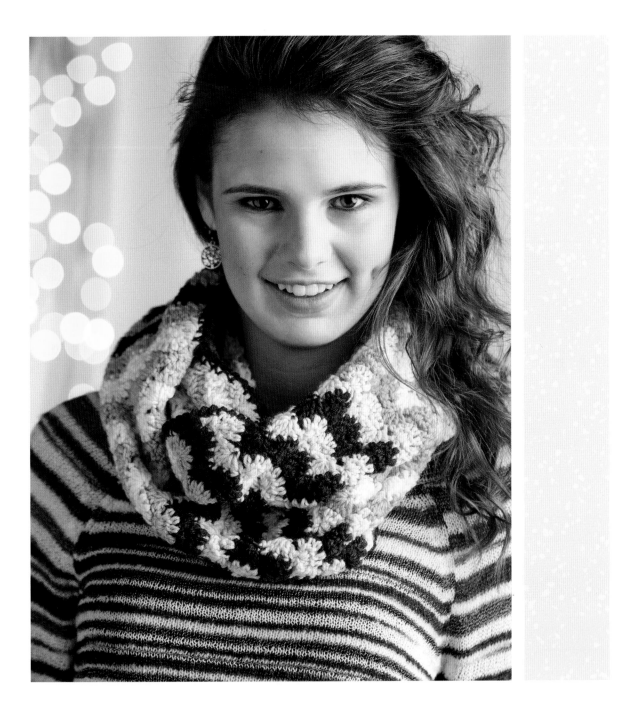

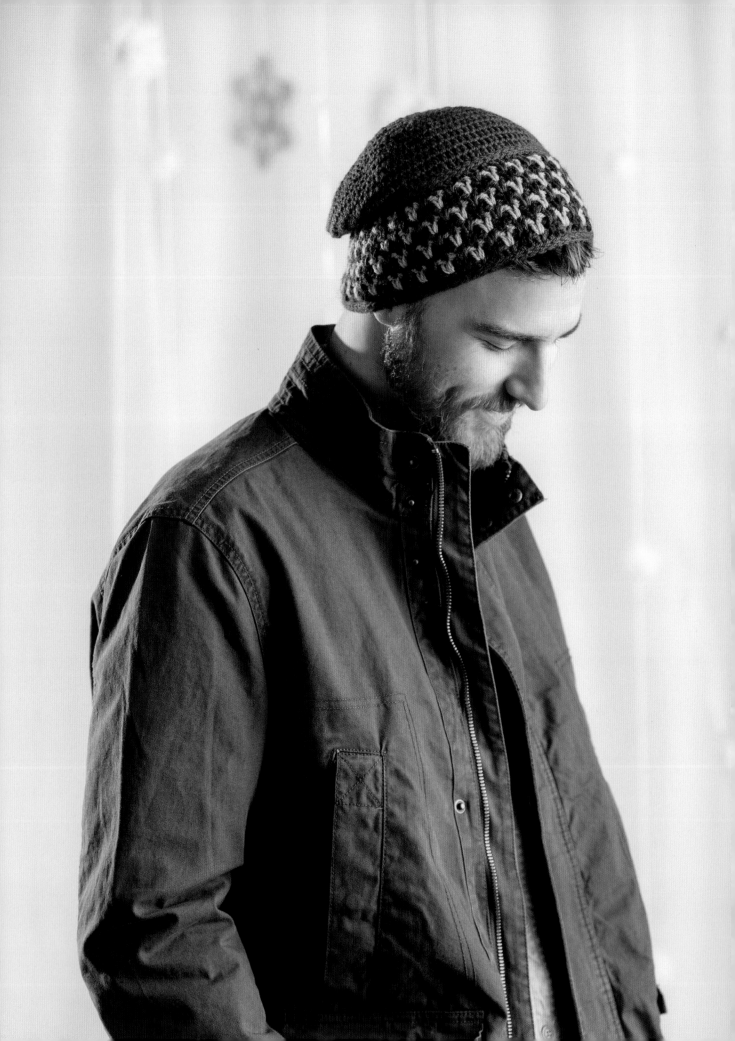

ULTRA ALPACA HAT

The body of this hat is made using three colors of yarn in a stitch pattern that alternates their placement. If you wanted, you could stop once the body is finished and have a nice headband/ear cover.

FINISHED MEASUREMENTS
8½" (21.5 cm) deep by 21" (53.5 cm) in circumference.

YARN WEIGHT
Worsted weight (#4 Medium).

Shown here: Berroco Ultra Alpaca (50% wool, 50% alpaca, 215 yd [197 m]/3½ oz [100 g]): #6213 Blue Glasynys (A), #62171 Berry Pie Mix (B), #6218 Oregano (C), 1 skein each.

HOOK
Size G-6/4 mm hook. *Adjust hook size if necessary to obtain the correct gauge.*

NOTIONS
Yarn needle.

GAUGE
18 sts = 4" (10 cm); 8 rows in V-st pattern = 2" (5 cm).

STITCH GUIDE

V-st: (Dc, ch 1, dc) in same st.

Standing double crochet (standing dc): Place a sl knot on hook, yo, insert the hook in the designated st, yo, draw up a lp (3 lps on hook), [yo, draw yarn through 2 lps on hook] twice.

HAT
BRIM

With A, ch 100, join with a sl st in the first ch to form a ring.

Rnd 1: (RS) Ch 3 (counts as dc, ch 1), dc in same ch as join (counts as V-st), *ch 1, sk next 3 chs, V-st in next ch; rep from * around to last 3 ch-sts, ch 1, join with a sl st in 2nd ch beg w ch-3. Fasten off A.

Rnd 2: (RS) With RS facing and working over sts in previous rnd, join B with standing dc in 2nd ch of the 3 skipped chs in foundation ch bet 2 V-sts, ch 1, dc in same ch, *ch 1, V-st in 2nd ch of next group of 3 skipped scs in foundation ch; rep from * around, join with a sl st in first dc. Fasten off B.

Rnd 3: (RS) With RS facing and working over sts in previous rnd, join C with standing dc in ch-1 sp of any V-st 2 rows below, ch 1, dc in same sp, *ch 1, V-st in ch-1 sp of the next V-st 2 rows below; rep from * around, join with a sl st in first dc. Fasten off C.

Rnds 4–13: Rep Rnd 3 working in the following color sequence: 1 rnd each of *A; B; C; rep from * throughout, ending with A.

BODY

Rnd 1: Ch 1, sc in each st and ch-1 sp around, join with sl st in first sc—100 sc.

Rnd 2: Ch 1, and working in back hump of sts, sc in each sc around, join with a sl st in first sc.

Rnd 3: Ch 2 (does not count as a st here and throughout), working in back hump of sts, hdc in each sc around, join with a sl st in first hdc— 100 hdc.

Rnds 4–9: Ch 2, hdc in each hdc around, join with a sl st in first hdc.

CROWN

Rnd 1 (dec rnd): Ch 2, *hdc2tog over the next 2 sts, hdc in each of the next 3 sts; rep from * around, join with a sl st in first hdc—80 sts.

Rnds 2, 4, and 6: Ch 2, hdc in each st around, join with a sl st in first hdc.

Rnd 3 (dec rnd): Ch 2, *hdc2tog over the next 2 sts, hdc in each of the next 2 sts; rep from * around, join with a sl st in first hdc—60 sts.

Rnd 5 (dec rnd): Ch 2, *hdc2tog over the next 2 sts, hdc in the next st; rep from * around, join with a sl st in first hdc—40 sts.

Rnds 7 and 8 (dec rnd): Ch 2, *hdc2tog over the next 2 sts; rep from * around, join with a sl st in first hdc —10 sts rem. Fasten off, leaving a sewing length of yarn.

FINISHING

Use a sewing length of yarn to sew the top of the crown closed. Weave in the ends.

EDGING

With RS facing and working across the opposite side of the foundation ch, join A with a sl st in any ch, ch 1, sl st in each ch around, join with a sl st in first sl st. Fasten off. Weave in the ends.

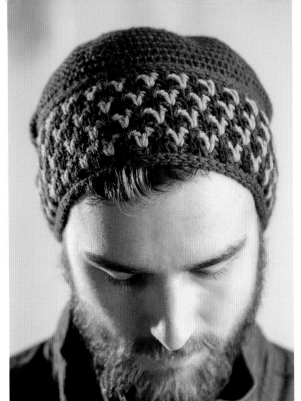

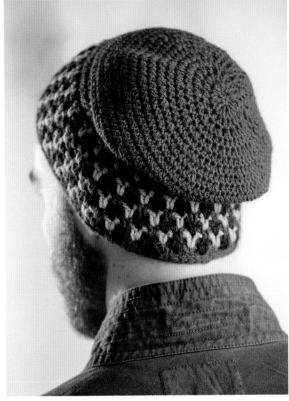

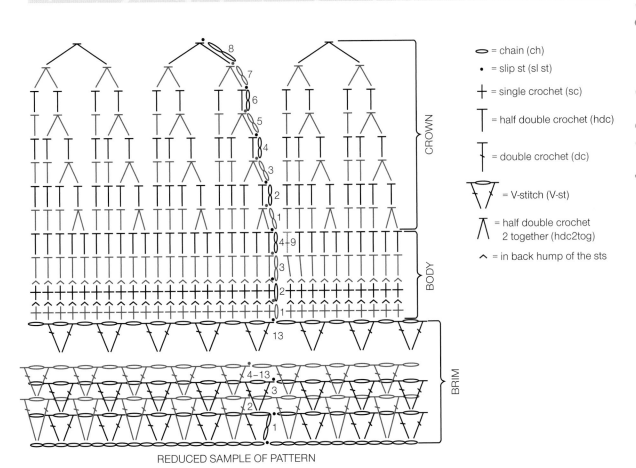

= chain (ch)

• = slip st (sl st)

+ = single crochet (sc)

T = half double crochet (hdc)

= double crochet (dc)

= V-stitch (V-st)

= half double crochet
2 together (hdc2tog)

⌃ = in back hump of the sts

CROWN

BODY

BRIM

REDUCED SAMPLE OF PATTERN

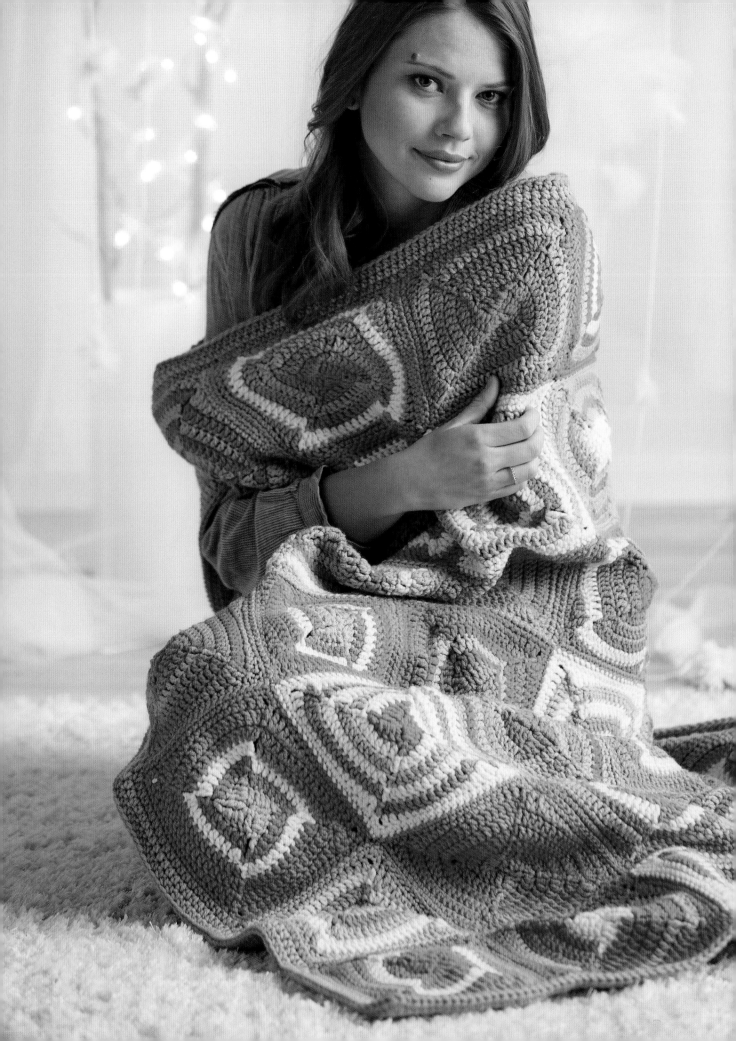

TILT-O-WHIRL AFGHAN

My daughter fell in love with this afghan as soon as she saw it. The modern geometric shape of the motifs in trendy colors makes a fun afghan. The solid fabric of the motif makes this a very warm blanket. For the seam, I did not want to take away from either side of the afghan, so I used a mattress stitch to invisibly join the motifs!

FINISHED MEASUREMENTS
48" (122 cm) by 48" (122 cm).

YARN
Worsted weight (#4 Medium).

Shown here: Red Heart With Love (100% acrylic, 370 yd [338 m]/7 oz [198 g]); #1252 Mango (A), #1502 Iced Aqua (B), #1308 Tan (C), #1703 Candy Pink (D), 2 skeins each.

HOOK
Size H-8/5mm hook. *Adjust hook size if necessary to obtain the correct gauge.*

NOTIONS
Yarn needle.

GAUGE
First 2 rnds = 3" (7.5 cm) in diameter. Each motif = 6½" (16.5 cm) by 6½" (16.5 cm).

NOTE

❋ Mix and match the color
combinations in the motifs.

TILT-O-WHIRL MOTIF

Make 49 motifs.

Rnd 1: With the first color, ch 6 (first ch counts as center ring), sc in the 3rd ch from the hook, 3 dc around the post of the next ch-3 length, tr in the first ch of beg ch-6 (ring), *dc in ring, ch 3, sc in the 3rd ch from the hook, 3 dc around the post of the last dc, tr in ring; rep from * twice, join with a sl st to the 3rd ch of the beg ch-6. Fasten off first color.

Rnd 2: With right side facing, join the next color with a sl st in any ch-2 corner sp, *ch 3, 2 dc in same sp, dc in the next sc, dc in the next 4 sts, sl st in the next ch-2 corner space; rep from * around. Fasten off.

⊖ = chain (ch)

• = slip st (sl st)

+ = single crochet (sc)

⊤ = half double crochet (hdc)

⊤ = double crochet (dc)

⊤ = treble crochet (tr)

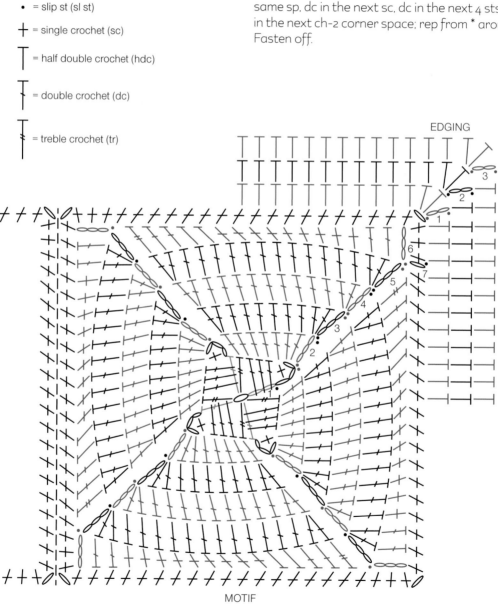

EDGING

MOTIF

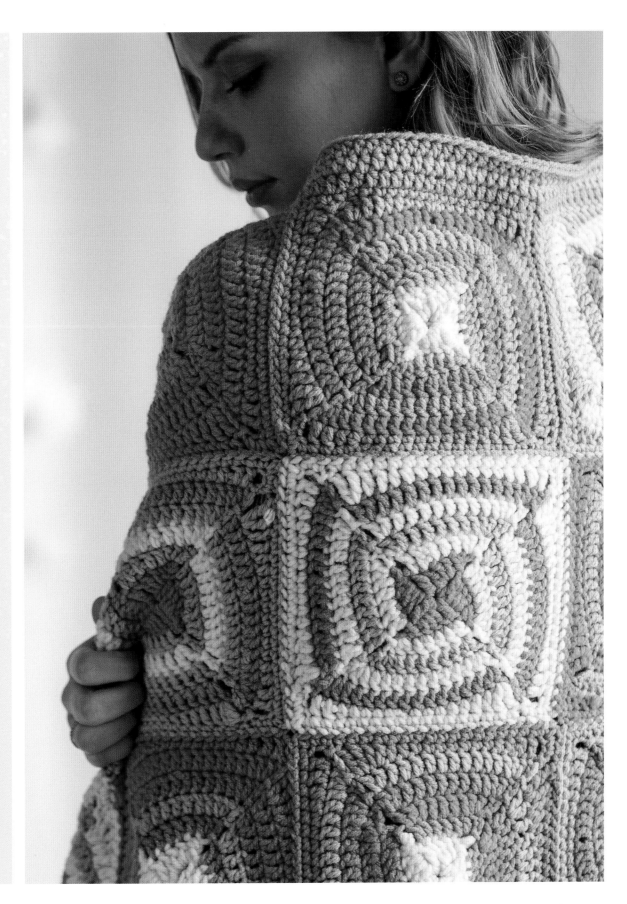

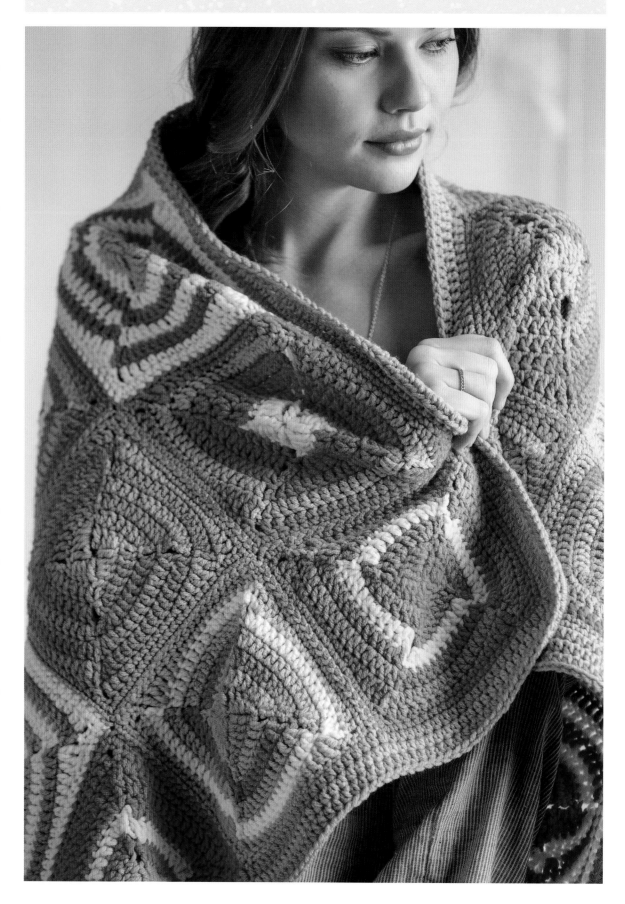

Rnd 3: With right side facing, join the next color with a sl st in the 3rd ch of any ch-3 corner, *ch 3, 2 dc in the same sp, dc in each of the next 6 dc, 2 dc in the next dc, sl st in the 3rd ch of the next ch-3; rep from * around. Fasten off.

Rnd 4: With right side facing, join the next color with a sl st in the 3rd ch of any ch-3 corner, *ch 3, 2 dc in the same sp, dc in each of the next 9 dc, 2 dc in the next dc, sl st in the 3rd ch of the next ch-3; rep from * around. Fasten off.

Rnd 5: With right side facing, join the next color with a sl st in the 3rd ch of any ch-3 corner, *ch 3, 2 dc in the same sp, dc in each of the next 12 dc, 2 dc in the next dc, sl st in the 3rd ch of the next ch-3; rep from * around. Fasten off.

Rnd 6: With right side facing, join the next color with a sl st in the 3rd ch of any ch-3 corner, *ch 3, dc in each of the next 2 dc, hdc in each of the next 2 dc, sc in each of the next 7 sc, hdc in each of the next 2 dc, dc in each of the next 2 dc, 2 tr in each of the next dc, sl st in the 3rd ch of the next ch-3; rep from * around. Do not fasten off.

Rnd 7: With the same color, ch 1, *sc in each of the next 2 ch sts, (sc, ch 1, sc) in the next ch, sc in the next 16 sts, sc in the next sl st; rep from * around, join with a sl st in the first sc. Fasten off.

FINISHING

Weave in the ends. Block all squares to the same measurements. Join the squares with the mattress stitch in a square 7 motifs wide by 7 motifs deep.

EDGING

Rnd 1: With the right side facing, join the next color with a sl st in the 3rd ch of any ch-3 corner, ch 2, 2 hdc in the same st, *hdc in each st across

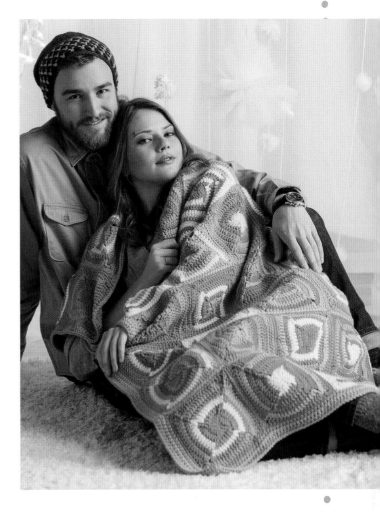

to the next corner**, 3 hdc in the next corner; rep from * around, ending the last rep at **, join with a sl st in the top of beg ch-2. Fasten off.

Rnds 2-3: With the right side facing, join the next color with a sl st in the center hdc in any 3-hdc corner, ch 2, 2 hdc in the same st, *hdc in each hdc to the next corner**, 3 hdc in the next corner; rep from * around, ending last rep at **, join with a sl st in the top of beg ch-2. Fasten off.

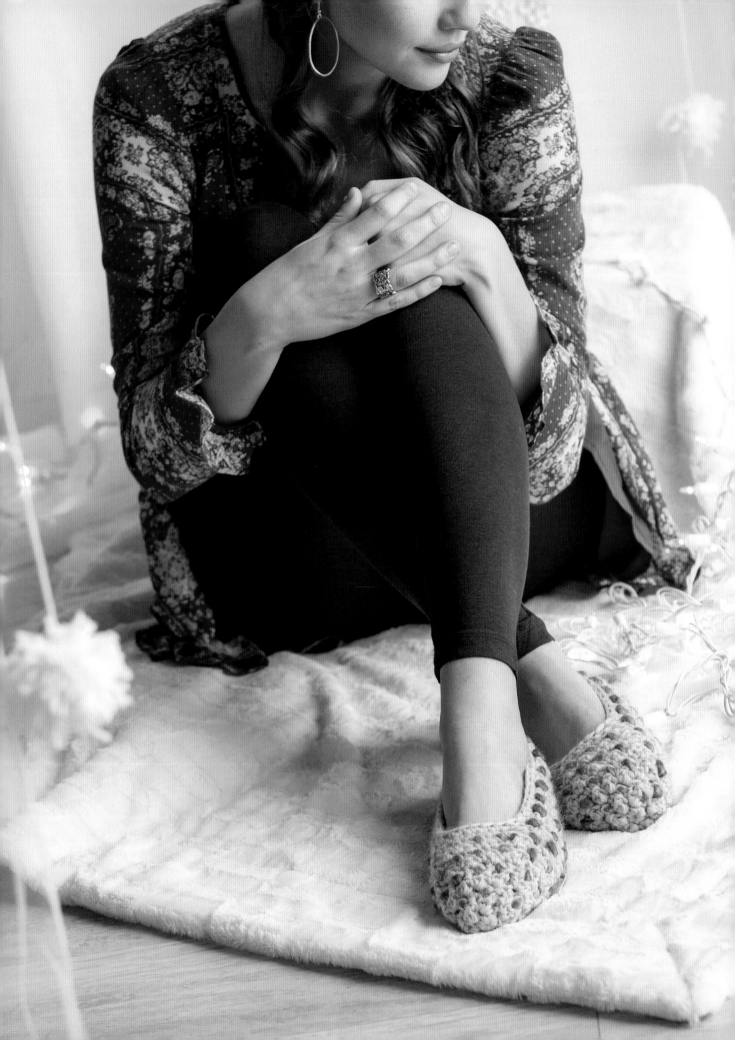

THRUMMED SLIPPERS

Take a basic slipper pattern and add thrums and you get a heavenly cloud for your feet. Mix and match the color of the thrums to make these your own.

FINISHED MEASUREMENTS
7 (8, 9, 10)" (18 [20.5, 23, 25.5] cm) long. Shown in size 9" (23 cm).

Directions are given for size Small. Changes for Medium, Large, and XL are in parentheses.

YARN
Worsted weight (#4 Medium).

Shown here: Cascade Yarns 220 (100% Peruvian Wool, 220 yd [201 m]/3½ oz [100 g]): #8011 Aspen Heather (A), 1 skein.

Twisted Fiber Art Divine Roving Fiber (50% cultivated silk, 50% merino wool), Roy G. Biv, about 2 oz (56 g).

HOOK
Size I-9/5.5 mm hook. *Adjust hook size if necessary to obtain the correct gauge.*

NOTIONS
Stitch markers; yarn needle.

GAUGE
With 2 strands of A held together as one, 12 sts and 10 rows = 4" (10 cm) in pattern.

NOTES

* Hold the yarn in double strands throughout.

* A thrum is a lock of fleece about 4" (10 cm) long with both ends folded to the middle and then twisted/rubbed tog. Middle of the thrum should not be any thicker than the yarn being used for the slipper.

* Make thrums prior to beginning the slipper.

* Work all thrums in dc sts every RS rnd (thrum tufts will be on WS).

* All increases and decreases will be completed in a non-thrum rnd.

* Slippers are worked from the toe up.

STITCH GUIDE

Double crochet 2 together (dc2tog): [Yo, insert hook in the next indicated st, yo, draw yarn through st, yo, draw yarn through 2 lps on hook] twice, yo, draw yarn through 3 lps on hook.

Single crochet 2 together (sc2tog): Insert the hook in the next st, yo, draw yarn through st, insert the hook into the next st, yo, draw yarn through st, yo, draw yarn through 3 lps on hook.

Double crochet with thrum (dcwt): Yo, insert hook in the next sc, fold the middle of thrum over throat of hook and yo, pull thrum and yarn through st, wrap tail of thrum clockwise around yarn and hold it tight so it does not untwist, yo with yarn only and draw through (lp, thrum, and lp), tug yarn, yo with yarn only and draw through 2 lps.

SLIPPERS (MAKE 2)
TOE

Make an adjustable ring.

Rnd 1: (RS) Work 6 sc in ring, join with a sl st in the first sc, turn—6 sc.

Rnd 2: (WS) Ch 2 (does not count as a st here and throughout), (sc, dc) in each sc around, join with a sl st in the top of the tch, turn—12 sts.

Rnd 3: (RS) Ch 2, *sc in next dc, dcwt (see Stitch Guide) in next sc; rep from * around, join with a sl st in the top of tch, turn—12 sts.

Rnd 4: (WS) Ch 2, (sc, dc) in each st around, join with a sl st in the top of tch, turn—24 sts.

Rnd 5: (RS) Rep Rnd 3, turn—24 sts.

Rnd 6: (WS) Ch 2, *(sc, dc) in each of the next 2 sts, [sc in the next st, dc in the next st] 5 times; rep from * around, join with a sl st in the top of tch, turn—28 sts.

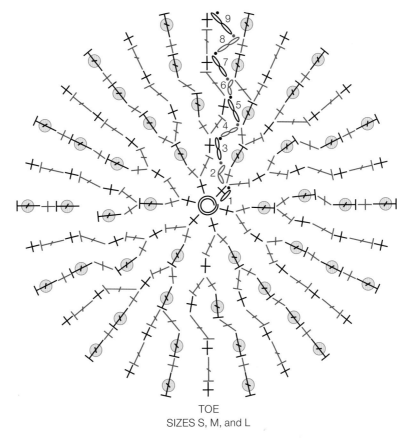

TOE
SIZES S, M, and L

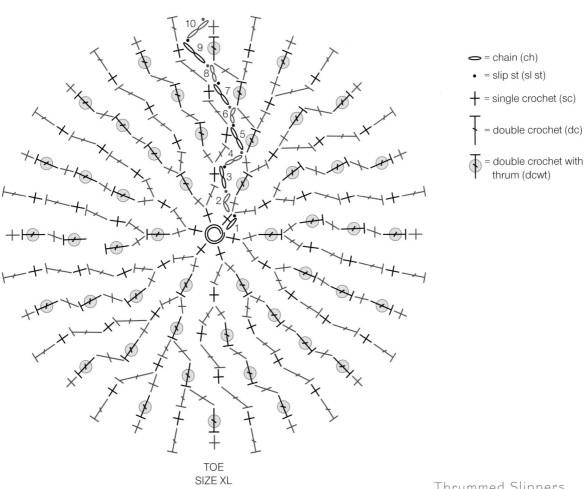

TOE
SIZE XL

◯ = chain (ch)

• = slip st (sl st)

✛ = single crochet (sc)

┰ = double crochet (dc)

┰ = double crochet with
thrum (dcwt)

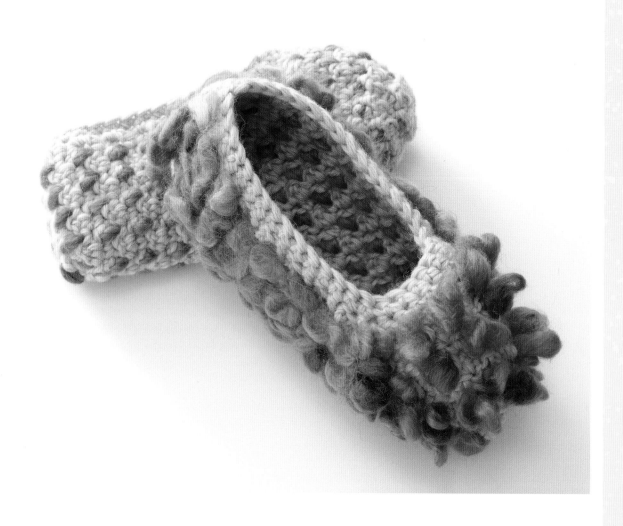

Rnd 7: (RS) Rep Rnd 3, turn—28 sts.

Sizes S, M, and L only
Rnd 8: (WS) Ch 2, *sc in the next st, dc in the next st; rep from * around, join with a sl st in the top of the tch, turn.

Rep Rnds 7–8 until the Toe measures about 3" (7.5 cm) from the beg desired length for the top of the slipper, ending with Rnd 7. Skip to the Foot Opening.

Size XL only
Rnd 8: (WS) Ch 2, *(sc, dc) in each of the next 2 sts, [sc in the next st, dc in the next st] 6 times; rep from * around, join with a sl st in the top of the tch—32 sts.

Rnd 9: (RS) Rep Rnd 5, turn.

Rnd 10: (WS) Ch 2, *sc in the next st, dc in the next st; rep from * around, join with a sl st in the top of the tch, turn.

Rep Rnds 9–10 until the Toe measures about 3½" (9 cm) from the beg desired length for the top of the slipper, ending with Rnd 9.

All sizes
Make foot opening:

Row 1: (WS) Ch 2, *sc in the next st, dc in the next st; rep from * 9 (9, 9, 11) times, turn, leaving rem sts unworked—20 (20, 20, 24) sts, 8 sts left unworked.

Row 2: (RS) Ch 2, *sc in the next dc, dcwt in the next sc; rep from * across, turn.

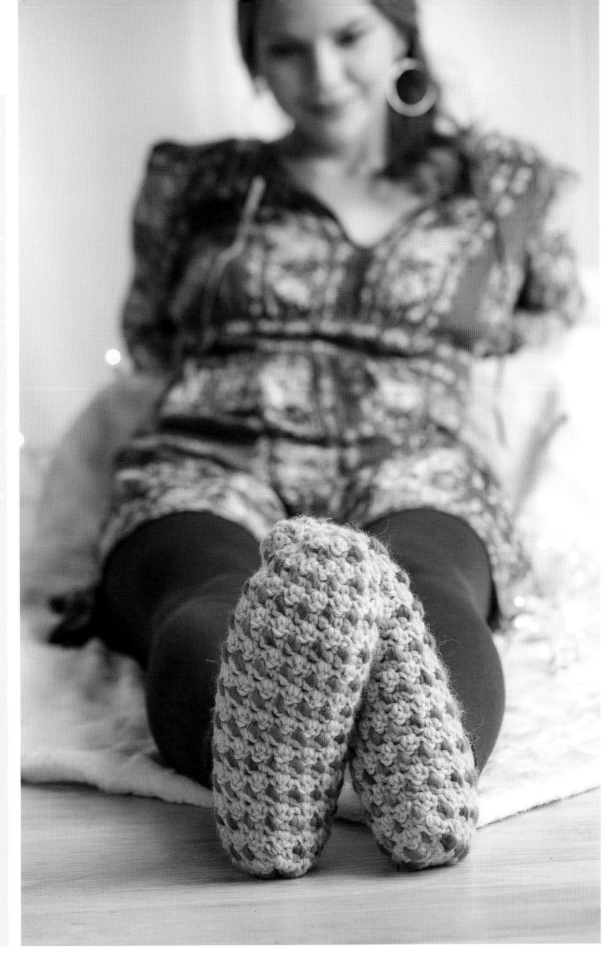

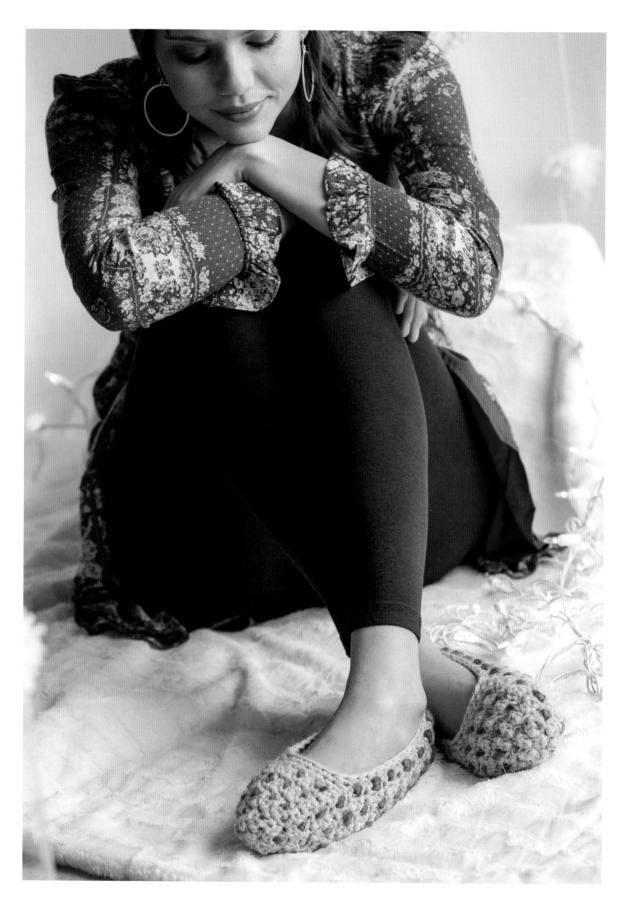

Row 3: (WS) Ch 2, *sc in the next dc, dc in the next sc; rep from * across, turn.

Rep Rows 2–3 until the Slipper measures 7 (8, 9, 10)" (18 [20.5, 23, 25.5] cm) from the beg, ending with Row 3 of the pattern.

Joining Row : (RS) Fold the slipper in half and working through a double thickness, sl st in each st across to join the back of the slipper. Fasten off.

Edging Row: With RS facing, join with a sl st to the back of the slipper, ch 1, sc evenly around the Foot Opening, working sc2tog at each inside corner where the sts go from rnds to rows. Fasten off.

FINISHING
Weave in the ends.

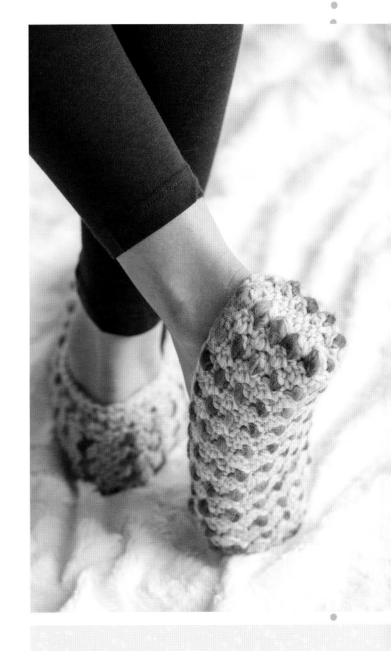

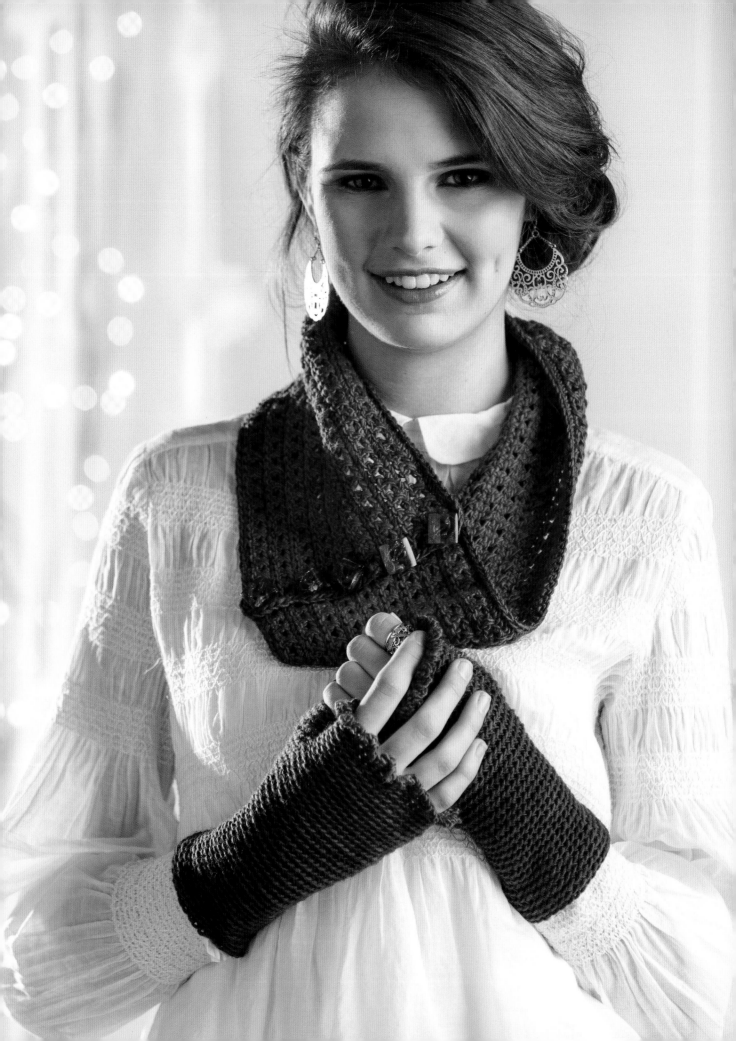

OMBRÉ COWL
&
FINGERLESS MITTS

The yarn is really the star with this coordinating set. The natural color change in the yarn is used to its full advantage by making both mitts at the same time. Then, using the remainder of the balls of yarn, crochet the cowl with one color fading into another and then back again. Decorative buttons really add a punch to this piece. These pieces can be worn together or separately.

FINISHED MEASUREMENTS
Mitts: 6½" (16.5 cm) in circumference around hand by 8" (20.5 cm) long.

Cowl: 5¾" (14.5 cm) wide by 30" (76 cm) long.

YARN
Sportweight (#3 Light).

Shown here: Knitwhits Freia Handpaints Freia Ombré Sport (100% wool, 217 yd [198 m]/2½ oz [71 g]): Cochinilla Ombré Sport, 2 balls.

HOOK
Size I-9/5.5 mm hook. *Adjust hook size if necessary to obtain the correct gauge.*

NOTIONS
Removable markers; yarn needle; 5 decorative buttons; sewing needle; matching sewing thread.

GAUGE
Mitts: 5 sts and 5 rows = 1" (2.5 cm) in sc-blo pattern.

Cowl: 8 cross sts and 12 rows = 4" (10 cm) in pattern.

NOTES

* Each fingerless mitt is made at the same time with separate balls of yarn. To make the mitts match, begin at the same point in the color sequence from each ball. When the mitts are completed, the remaining yarn will be used for the cowl.

* Markers will help you keep track of the increases on the gusset.

Note: If you make the mitts at the same time, it's easier to make sure they match along the way.

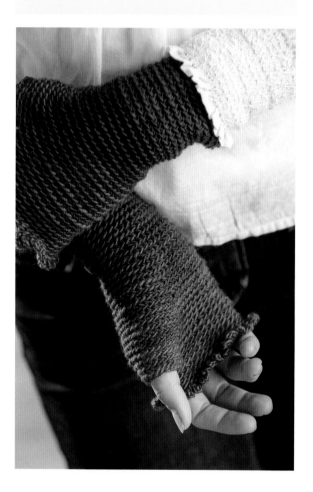

STITCH GUIDE

Crossed double crochet (crossed dc): Sk next st, dc in next st; working over last dc, dc in last skipped st.

MITTS
CUFF
Ch 34.

Rnd 1: Sc-blo in 2nd ch from hook and in each ch across, join with sl st in first sc-blo—33 sc-blos.

Rnd 2: Ch 1, sc-blo in each sc around, join with sl st in first sc-blo.

Rnds 3–12: Rep Rnd 2.

GUSSET THUMB

Rnd 1: Ch 1, sc-blo in each of the next 3 sts, place marker in st just made, 2 sc-blo in the next st, sc-blo in the next st, 2 sc-blo in the next st, sc-blo in the next st, then place a marker in st just made, sc-blo in each st around, join with a sl st in first sc-blo—5 sc-blo bet gusset markers.

Rnds 2, 4, 6, 8, 10, 12, 14, 16, and 18: Ch 1, sc-blo in each st around, join with a sl st in first sc-blo.

Rnd 3: Ch 1, sc-blo in each of the next 3 sts, place a marker in st just made, 2 sc-blo in the next st, sc-blo in each of the next 3 sts, 2 sc-blo in the next st, sc-blo in the next st, place a marker in st just made, sc-blo in each st around around, join with a sl st in first sc-blo—7 sc-blo bet gusset markers.

Rnd 5: Ch 1, sc-blo in each of the next 3 sts, place a marker in st just made, 2 sc-blo in the next st, sc-blo in each of the next 5 sts, 2 sc-blo in the next st, sc-blo in the next st, place a marker in st just made, sc-blo in each st around, join with a sl st in first sc-blo—9 sc-blo bet gusset markers.

Rnd 7: Ch 1, sc-blo in each of the next 3 sts, place a marker in st just made, 2 sc-blo in the next st, sc-blo in each of the next 7 sts, 2 sc-blo in the next st, sc-blo in the next st, place a marker in st just made, sc-blo in each st around, join with a sl st in first sc-blo—11 sc-blo bet gusset markers.

Rnd 9: Ch 1, sc-blo in each of the next 3 sts, place a marker in st just made, 2 sc-blo in the next st, sc-blo in each of the next 9 sts, 2 sc-blo in the next st, sc-blo in the next st, place a marker in st just made, sc-blo in each st around, join with a sl st in first sc-blo—13 sc-blo bet gusset markers.

Rnd 11: Ch 1, sc-blo in each of the next 3 sts, place a marker in st just made, 2 sc-blo in the next st, sc-blo in each of the next 11 sts, 2 sc-blo in the next st, sc-blo in the next st, place a marker in st just made, sc-blo in each st around, join with a sl st in first sc-blo—15 sc-blo bet gusset markers.

Rnd 13: Ch 1, sc-blo in each of the next 3 sts, place a marker in st just made, 2 sc-blo in the next st, sc-blo in each of the next 13 sts, 2 sc-blo in the next st, sc-blo in the next st, place a marker in st just made, sc-blo in each st around, join with a sl st in first sc-blo—17 sc-blo bet gusset markers.

Rnd 15: Ch 1, sc-blo in each of the next 3 sts, place a marker in st just made, 2 sc-blo in the next st, sc-blo in each of the next 15 sts, 2 sc-blo in the next st, sc-blo in the next st, place a marker in st just made, sc-blo in each st around, join with a sl st in first sc-blo—19 sc-blo bet gusset markers.

Rnd 17: Ch 1, sc-blo in each of the next 3 sts, place a marker in st just made, 2 sc-blo in the next st, sc-blo in each of the next 17 sts, 2 sc-blo in the next st, sc-blo in the next st, place a marker in st just made, sc-blo in each st around, join with a sl st in first sc-blo—21 sc-blo bet gusset markers.

SEPARATE GUSSET THUMB

Rnd 1: Ch 1, sc-blo in each of the next 3 sts, ch 3, skip the next 21 sts (gusset), sc-blo in each st around, join with a sl st in first sc-blo—30 sc-blo; one ch-3 sp.

Rnd 2: Ch 1, sc-blo in each st around, join with a sl st in first sc-blo—33 sc-blo.

Rnds 3–9: Rep Rnd 2.

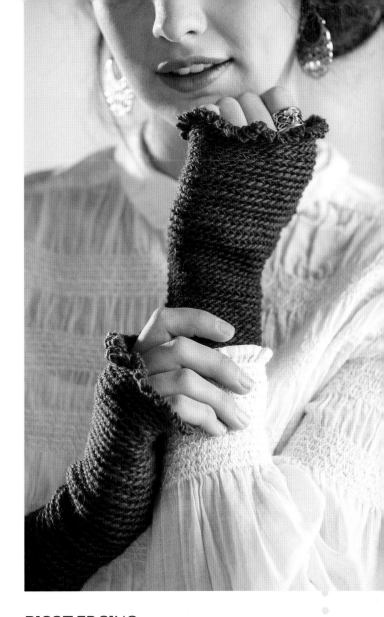

PICOT EDGING

Rnd 1: Ch 4, sl st in the next st; rep from * around, join with a sl st in first st. Fasten off.

THUMB

Rnd 1: With RS facing, join yarn with a sl st in first st on Gusset to the right of the ch-3 section of Thumb opening, sc3tog-blo over the next 3 ch sts, sc-blo in each st around the thumb opening, join with a sl st in first sc-blo—22 sts.

Rnds 2–4: Ch 1, sc-blo in each st around, join with a sl st in first sc-blo. Fasten off.

FINISHING

Weave in the ends.

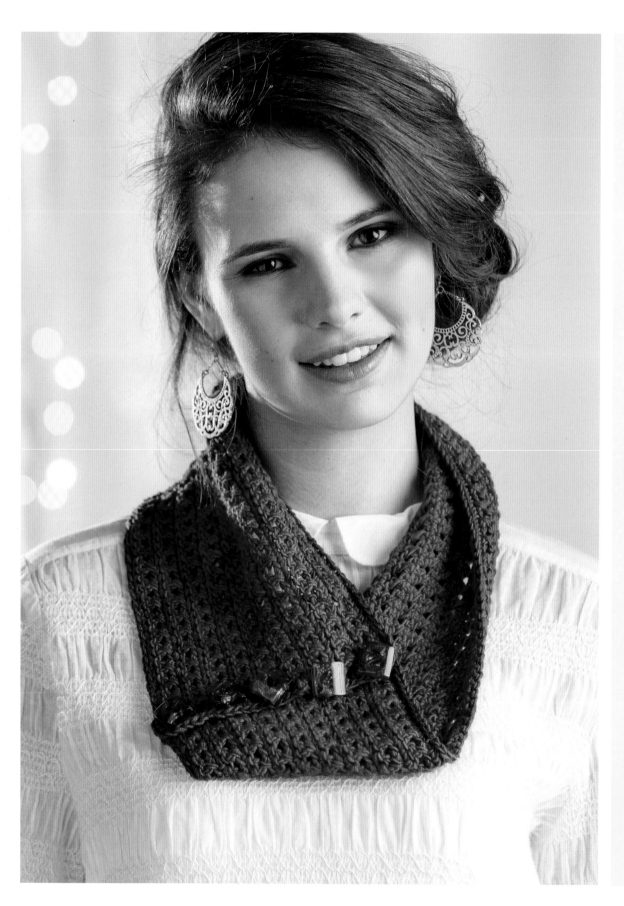

COWL

Note: The cowl is made with the remaining yarn from the fingerless mitts. For the cowl to turn out like the sample, begin working with the darker shade of one of the balls; work about halfway through the cowl, letting the color change to a lighter shade. At the halfway point, change to the second ball of yarn at about the same point of the lighter ombré shade and work the rest of the cowl, letting the yarn gradually change to the darker shade to mirror the beginning of the cowl.

BODY

Ch 121.

Set-up Row: Sc in 2nd ch from hook and in each ch across, turn—120 sc.

Row 1: (RS) Ch 2 (does not count as a st), dc in first sc, *sk next sc, dc in the next sc, dc in the last skipped sc; rep from * across to the last ch, dc in the last ch, turn—2 dc, 59 crossed dc.

Row 2: (WS) Ch 1, sc in each st across, turn—120 sc.

Rows 3-18: Rep Rows 1-2 eight times.

TRIM

Rnd 1: (RS) Ch 1, sc in each st across to the next corner, ch 1, rotate cowl 90 degrees, *working across short edge of Cowl, sc evenly across, working sc in each row-end sc, 2 sc in each row-end dc across to the next corner, ch 1*, rotate cowl 90 degrees, working across opposite side of foundation ch, sc in each ch across to the next corner, ch 1, rotate cowl 90 degrees, rep from * to * across the second short edge, join with a sl st in the first sc. Fasten off.

FINISHING

Weave in the ends.

With sewing needle and thread, sew decorative buttons to sc edging on one short edge of Cowl next to the first, 3rd, 5th, 7th, and 9th cross st rows. Use spaces bet sts on other end of Cowl for buttonholes.

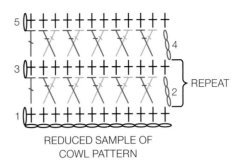

REDUCED SAMPLE OF
COWL PATTERN

⬭ = chain (ch)

+ = single crochet (sc)

= double crochet (dc)

= crossed double crochet (crossed dc)

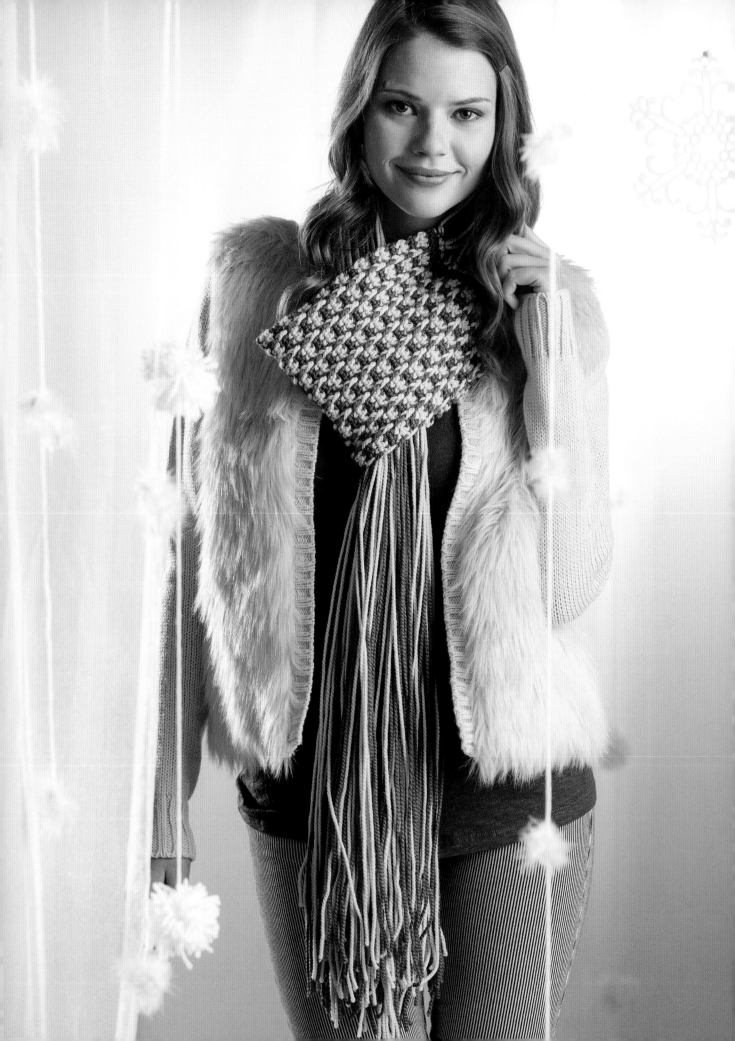

KEYHOLE
FRINGED SCARF

The unique construction of this scarf is fun for the crocheter and for the wearer. The fabric is crocheted to be a big keyhole for the fringe to thread through as it is worn around the neck. The bulky alpaca yarn makes this project soft and warm.

FINISHED MEASUREMENTS
Pocket 7" (18 cm) wide by 16" (40.5 cm) long before seaming. Tassels measure about 44" (112 cm).

YARN
Aran weight (#4 Medium).

Shown here: Blue Sky Alpacas Extra (55% alpaca, 45% merino, 218 yd [199 m]/51/3 oz [150 g]): #3519 Fedora (A) and CB, #3521 Lake Ice (B), 1 hank each.

HOOK
Size I-9/5.5 mm hook. *Adjust hook size if need to obtain the correct gauge.*

NOTIONS
Yarn needle.

GAUGE
15 sts and 18 rows in pattern = 4" (10 cm).

Note: To make sure there is enough yarn for the entire piece, make the fringe first.

NOTES

* Carry the colors not in use up the side of the scarf. Always skip one stitch behind each post stitch made.

STITCH GUIDE

Fringe: Cut lengths of yarn about 8' (244 cm) long so that when folded in half, the fringe is 4' (122 cm) long. Make 13 fringes using 4 lengths of yarn in each color per fringe.

REDUCED SAMPLE OF POCKET PATTERN

⌒ = chain (ch)

+ = single crochet (sc)

} = Front Post double crochet (FPdc)

POCKET

With A, ch 27.

Row 1: (WS) Sc in 2nd ch from hook and in each ch across, change to B in last st made, turn—26 sc.

Row 2: (RS) With B, ch 1, sc in each st across, turn.

Row 3: Ch 1, sc in each st across; change color to A in last st, turn.

Row 4: Ch 1, sc in the first 2 sc, *FPdc around the post of the next sc 3 rows below, sc in the next 2 sc; rep from * across, turn—8 FPdc.

Row 5: Ch 1, sc in each st across; change to B in last st, turn.

Row 6: Ch 1, sc in each of the first 2 sc, *FPdc around the post of the next FPdc 2 rows below, sc in each of the next 2 sc; rep from * across, turn—8 FPdc.

Row 7: Ch 1, sc in each st across; change to the next color in the sequence in last st, turn.

Rows 8-73: Rep Rows 6-7 (33 times) working in the following color sequence: *2 rows A; 2 rows B; rep from * ending with A. Do not fasten off.

FINISHING

Joining Row: Fold the pocket with the WS together. With A and working through the double thickness of the yarn, match the sts across the last row and the foundation ch; ch 1, sc in each st across. Fasten off.

FRINGE

Cut lengths of yarn as directed above. Using 4 strands each of A and B held together for each Fringe, fold the bundle of yarn in half. Insert the hook from the front to the back in the corner st of the Joining Row; pull the folded end of the Fringe through the st. Wrap the strands of yarn around the hook and draw the hook through the folded end. In the same manner, evenly space and attach the remaining 12 Fringes across the row. Evenly trim the edges of the Fringe. Weave in the ends.

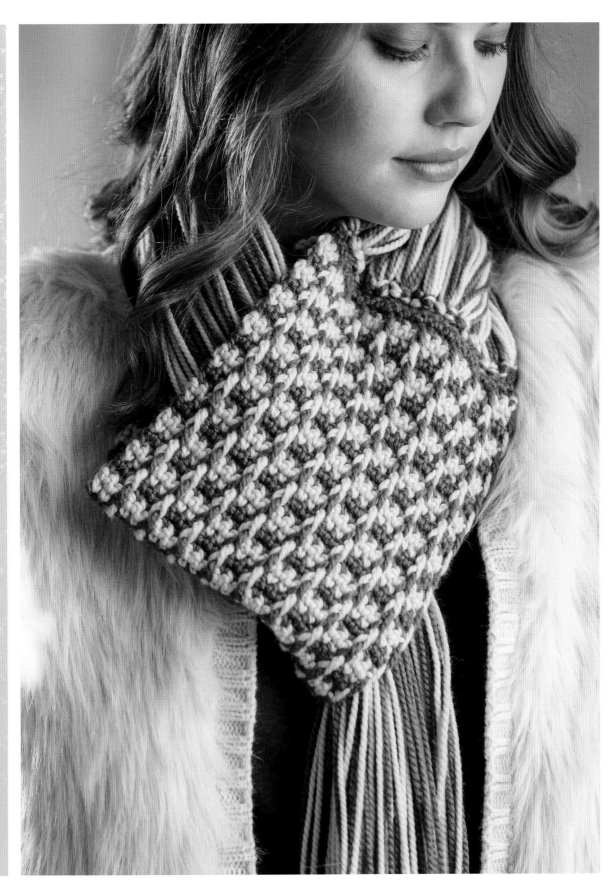

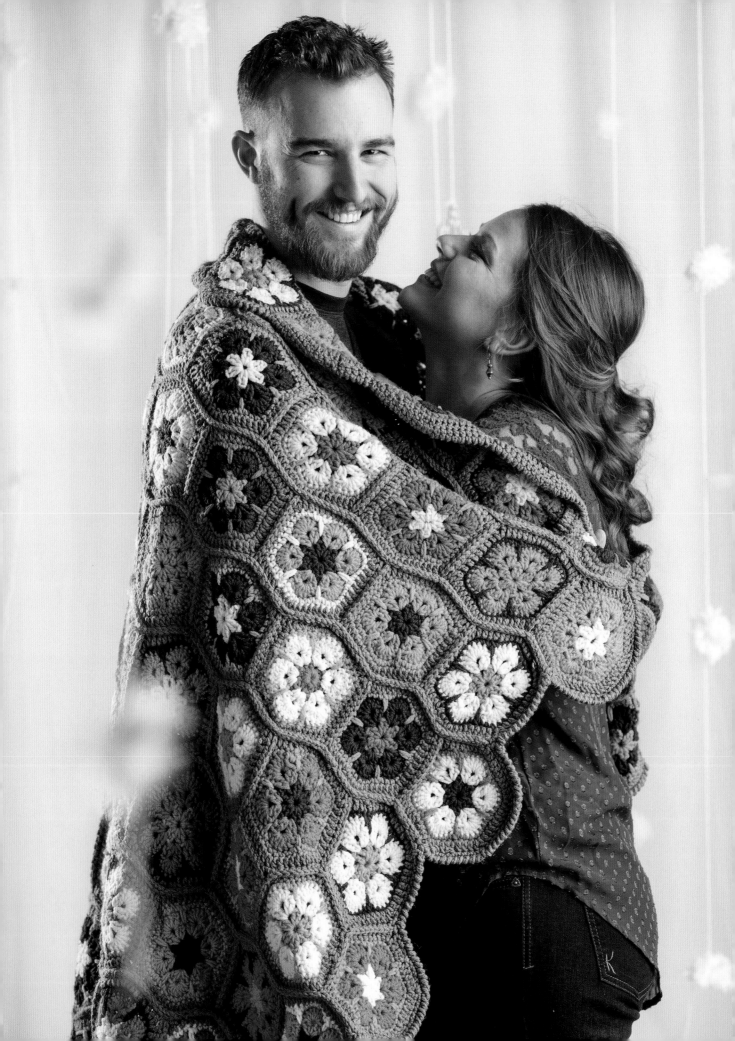

AFRICAN FLOWER
AFGHAN

This motif is one that is great to use with many color combinations. I chose to make this afghan with this motif in a variety of colors and then join them all with one solid color. The interesting part is using the seam as a design feature. I think it adds great texture to a beautiful piece!

FINISHED MEASUREMENTS
62" (157.5 cm) by 67" (162.5 cm).

YARN
Worsted weight (#4 Medium).

Shown here: Red Heart With Love (100% acrylic, 370 yd [338m]/7 oz [198 g]): #1401 Pewter (M), 5 skeins; #1101 Eggshell (A), #1542 Aborigine (B), and #1502 Iced Aqua (C), 1 skein each.

Red Heart Super Saver Economy (100% acrylic, 364 yd [333 m]/7 oz [198 g]): #512 Turqua (D) and #672 Spring Green (E), 1 skein each.

HOOK
Size H-8/5mm hook. *Adjust hook size if necessary to obtain the correct gauge.*

NOTIONS
Yarn needle.

GAUGE
Motif = 4¾" (12 cm) in diameter.

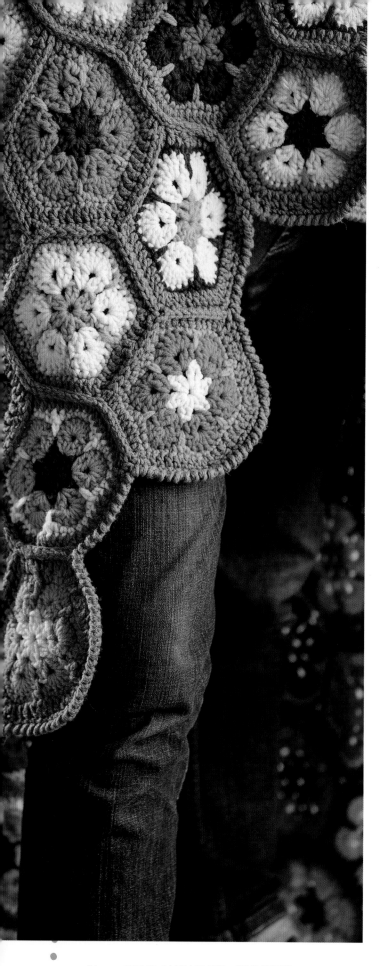

NOTES

* Mix and match color combinations for the first 4 rnds, then use the main color on the last rnd. The motifs are join-as-you-go after the first full motif is made. Always work with the RS facing.

STITCH GUIDE

Shell: (2 dc, ch 1, 2 dc) in same sp.

Beginning shell (beg shell): (Dc, ch 1, 2 dc) in same sp.

AFGHAN
AFRICAN FLOWER MOTIF
(MAKE 196)

Use any color combination.

With first color, ch 5, join with a sl st in first ch to form a ring.

Rnd 1: Ch 3 (counts as dc here and throughout), dc in ring, ch 1 [2 dc, ch 1] 5 times in ring, join with a sl st in top of beg ch-3—6 ch-1 sps; 12 dc. Fasten off first color.

Rnd 2: With RS facing, join the 2nd color in the last ch-1 sp, ch 3, beg shell in same sp, shell in each ch-1 sp around, join with a sl st in top of beg ch-3—6 shells.

Rnd 3: Sl st in the next dc and next ch-1 sp, ch 3, 6 dc in same ch-1 sp, 7 dc in each ch-1 sp around, join with a sl st in top of beg ch-3—42 dc. Fasten off 2nd color.

Rnd 4: With RS facing, join 3rd color in first st of the last rnd, ch 1, sc in each of first 7 sts, *working

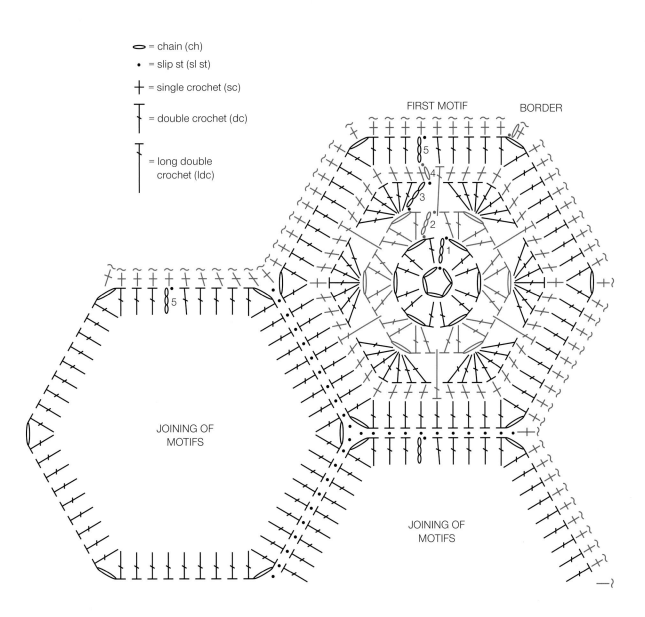

- ⬭ = chain (ch)
- • = slip st (sl st)
- ┼ = single crochet (sc)
- ⊤ = double crochet (dc)
- ⊤ = long double crochet (ldc)

FIRST MOTIF BORDER

JOINING OF MOTIFS

JOINING OF MOTIFS

over the last rnd and working a long dc in the sp between 2 shells 2 rnds below**, sc in each of the next 7 dc; rep from * around, ending the last rep at **, join with a sl st in first sc—42 sc; 6 long dc. Fasten off 3rd color.

Rnd 5: With RS facing, join 4th color in first st of the last rnd, ch 3, dc in each of the next 2 sc, *(dc, ch 1, dc) in the next sc**, dc in each of the next 7 sts; rep from * around, ending the last rep at **, join with a sl st in top of the beg ch-3—6 ch-1 sps; 54 dc. Fasten off 4th color. Weave in the ends.

Note: Take the time and weave in the ends as you go. Trust me, you'll be happier if you do.

JOINING MOTIFS INTO STRIPS

Joining Row: With WS of 2 Motifs facing and working through the double thickness of 2 Motifs, join the MC in the first corner, matching sts, sl st in each st across to the next corner. Fasten off. Join the next Motif on bottom edge of previous motif and continue joining until 14 Motifs have been joined in a Strip.

JOINING STRIPS

Joining Row: With WS of 2 strips facing and following the Assembly diagram for placement, join the MC in the first corner where the first and 2nd strip meet. Matching sts, sl st in each st

across the 14 Motifs to the last corner where the 2 Strips meet. Fasten off. Rep the Joining Row, joining the rem 12 Strips following the Assembly Diagram for placement.

BORDER

With colors facing, join the MC with a sl st in any corner of the afghan, ch 1, reverse sc in each st around, join with a sl st in the first reverse sc. Fasten off.

FINISHING

Weave in the ends. Wash the afghan in warm water according to yarn manufacturer's instructions and block to the finished size.

ASSEMBLY DIAGRAM

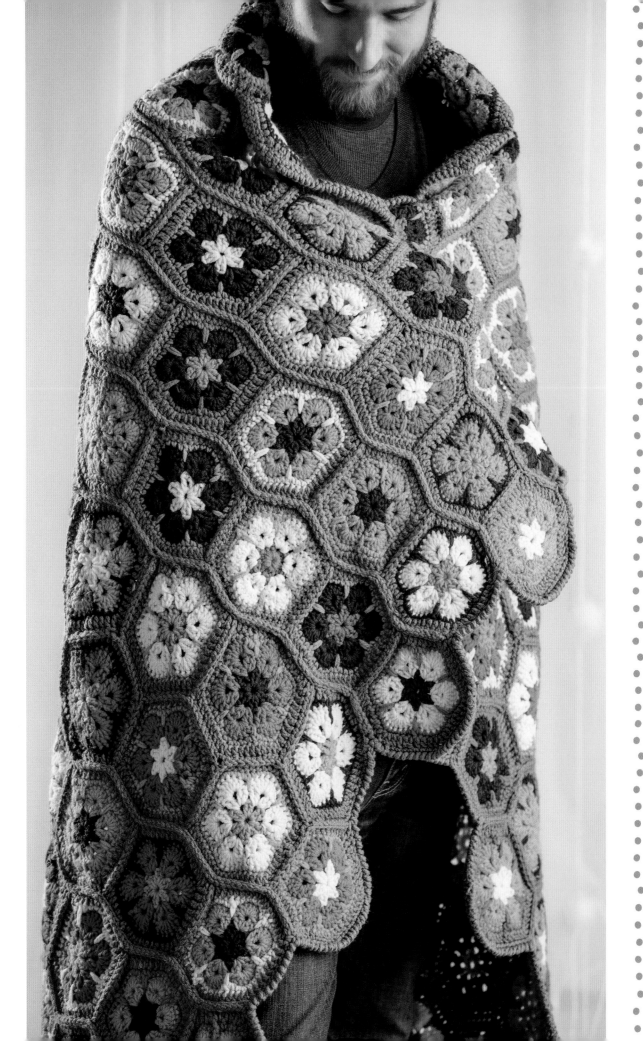

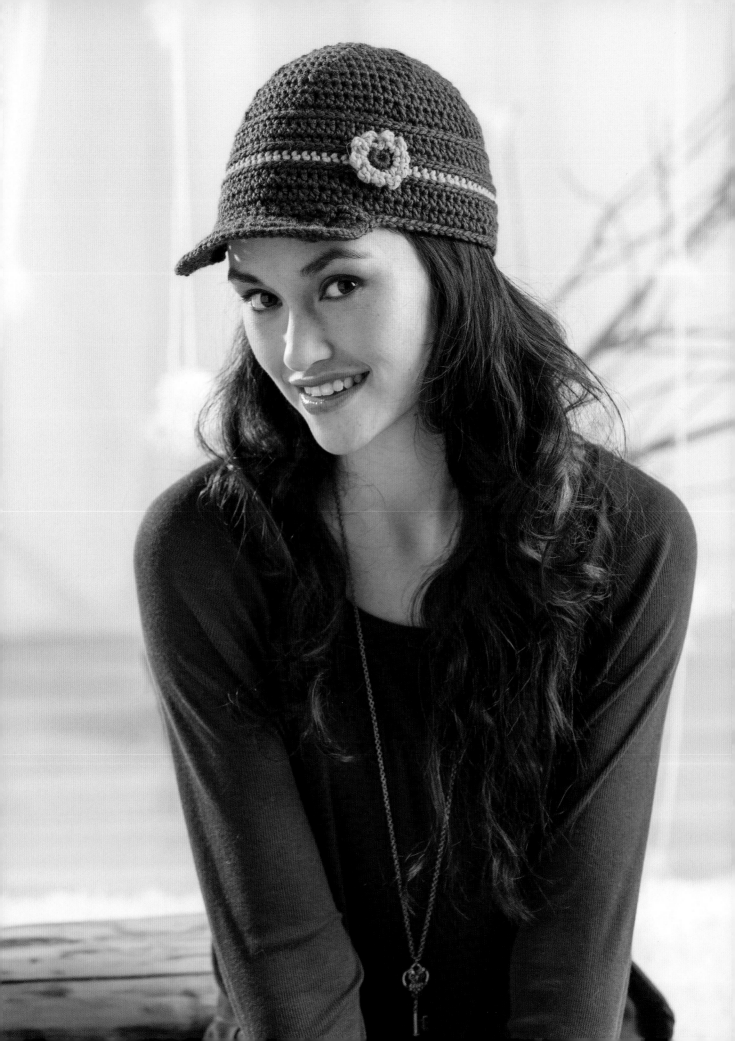

NEWSBOY
CAP

This on-trend cap uses simple stitches in a combination of ways to create an intriguing fabric around the body of the hat. The pop of color in the stripe, plus the flower, add a special something to any winter wardrobe. Finally, the brim holds its shape because it's made by crocheting around a pipe cleaner!

FINISHED MEASUREMENTS
7½" (19 cm) deep by 21" (53.5 cm) in circumference.

YARN
Worsted weight (#4 Medium).

Shown here: Blue Sky Alpacas Extra (55% alpaca, 45% merino, 218 yd [199 m]/5⅓ oz [150 g]): #3518 Java (A), #3514 Marsh (B), 1 hank each.

HOOK
Size I-9/5.5 mm hook. *Adjust hook size if necessary to obtain the correct gauge.*

NOTIONS
Yarn needle; pipe cleaner.

GAUGE
16 sts and 12 rows hdc = 4" (10 cm).

CAP

BODY

With A, ch 80, join with a sl st in the first ch to form a ring.

Rnds 1–3: (RS) Ch 2 (does not count as a st here and throughout), hdc in each ch around, join with a sl st in first hdc—80 hdc. Change to B on last st of last rnd.

Rnd 4: (RS) With B, ch 1; working in back hump of sts, sc in each st around, join with a sl st in first sc—80 sc. Change to A on last st of rnd.

Rnd 5: (RS) With A, ch 2, hdc in each sc around, join with a sl st in first hdc—80 hdc.

Rnd 6: (RS) Rep Rnd 4.

Rnds 7–8: (RS) Ch 2, hdc in each st around, join with a sl st in first hdc—80 hdc.

Rnd 9: (RS) Rep Rnd 4.

CROWN

Rnd 1: Ch 2, *hdc in each of the next 8 sts, hdc-2tog over the next 2 sts; rep from * around, join with a sl st in first hdc—72 sts.

Rnds 2,4, 6, 8, 10, 12, 14, and 16: Ch 2, hdc in each st around, join with a sl st in first hdc.

Rnd 3: Ch 2, *hdc in each of the next 7 sts, hdc-2tog over the next 2 sts; rep from * around, join with a sl st in first hdc—64 sts.

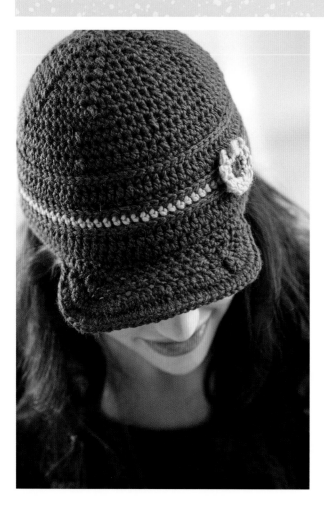

- ⬭ = chain (ch)
- • = slip st (sl st)
- ✛ = single crochet (sc)
- ⊤ = half double crochet (hdc)
- ⋀ = half double crochet 2 together (hdc2tog)
- ⌢ = in back hump of the st

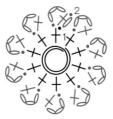

FLOWER

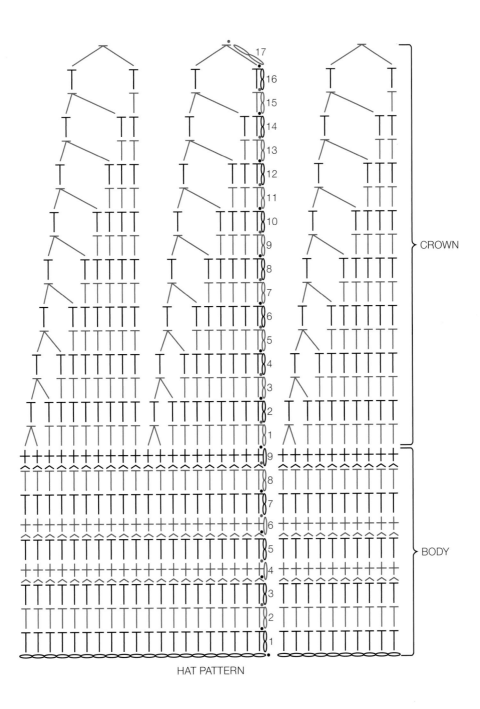

CROWN

BODY

HAT PATTERN

Rnd 5: Ch 2, *hdc in each of the next 6 sts, hdc-2tog over the next 2 sts; rep from * around, join with a sl st in first hdc—56 sts.

Rnd 7: Ch 2, *hdc in each of the next 5 sts, hdc-2tog over the next 2 sts; rep from * around, join with a sl st in first hdc—48 sts.

Rnd 9: Ch 2, *hdc in each of the next 4 sts, hdc-2tog over the next 2 sts; rep from * around, join with a sl st in first hdc—40 sts.

Rnd 11: Ch 2, *hdc in each of the next 3 sts, hdc-2tog over the next 2 sts; rep from * around, join with a sl st in first hdc—32 sts.

Rnd 13: Ch 2, *hdc in each of the next 2 sts, hdc-2tog over the next 2 sts; rep from * around, join with a sl st in first hdc—24 sts.

Rnd 15: Ch 2, *hdc in the next st, hdc2tog over the next 2 sts; rep from * around, join with a sl st in first hdc—16 sts.

Rnd 17: Ch 2, *hdc2tog over the next 2 sts; rep from * around, join with a sl st in first hdc—8 sts dec.

Fasten off.

BRIM
Row 1: (RS) Join A with a sl st around the pipe cleaner, ch 1, work 42 sc around the pipe cleaner, turn.

Row 2: (WS) Ch 1, *sc2tog over the next 2 sts; rep from * across, turn—21 sc.

Row 3: (RS) Ch 1, *sc2tog over the next 2 sts, sc in each st across to last 2 sts, sc2tog over last 2 sts. Fasten off.

Joining Row: With RS of Hat and Brim together and matching sts across the foundation ch of the Hat and last row of the Brim, work through the double thicknesses; sl st in each st across. Fasten off.

FINISHING
EDGING
With RS facing, join A with a sl st in any ch on the foundation ch at the back of the Hat, ch 1, sc around the bottom edge of the hat and across the edge of the brim to the beg, join with a sl st in the first sc.

Weave in the ends.

FLOWER
With A and leaving a sewing length of yarn, make an adjustable ring.

Rnd 1: Work 10 sc in ring, join with a sl st in first sc—10 sc. Fasten off A, join B.

Rnd 2: With B, ch 1, (sc, ch 3, sl st) in each sc around, join with a sl st in first sc. Fasten off.

With a sewing length of yarn, sew the Flower to Rnd 4 of the Hat as shown. Weave in the ends.

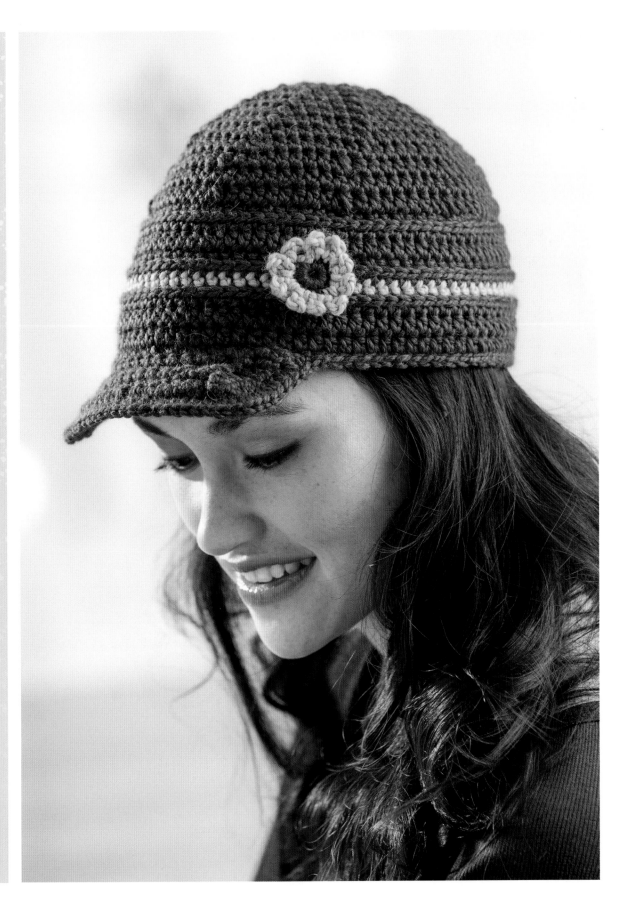

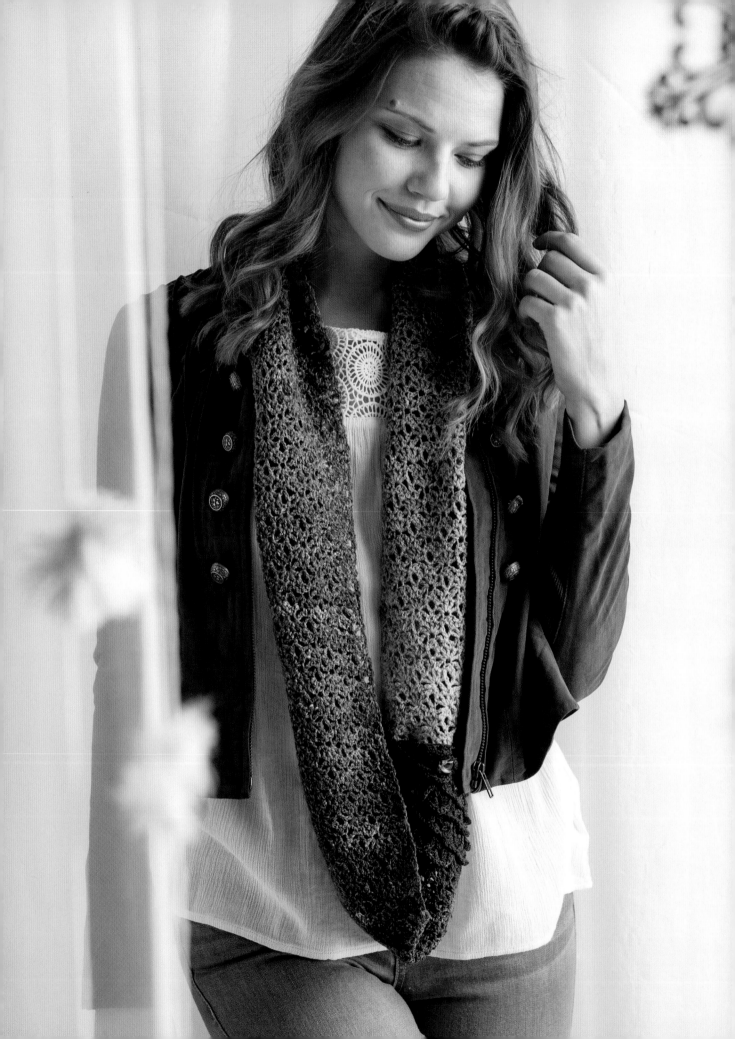

DENIM
INFINITY SCARF

Crochet lace creates a beautiful fabric, and when made with an ombré yarn, the effect is stunning. This cowl is made in one piece with the final portion in crocodile stitch. The natural opening in the middle of the crocodile stitch is used as a buttonhole to make this an infinity cowl.

FINISHED MEASUREMENTS
7" (18 cm) wide by 56" (142 cm) long after blocking.

YARN
Sportweight (#2 Fine).

Shown here: Freia Fine Handpaints Ombré Grande (75% wool, 25% nylon, 645 yd [590 m], 2.64 oz (75 g)): Denim Ombré, 1 ball.

HOOK
Size E-4/3.5 mm hook. *Adjust hook size if necessary to obtain the correct gauge.*

NOTIONS
Yarn needle; 4 buttons; sewing needle; matching sewing thread.

GAUGE
3 shells in pattern = 3½" (9 cm).
8 rows in pattern = 3" (7.5 cm).

STITCH GUIDE

Shell: ([Dc, ch 1] 4 times, dc) in same st.

2 double crochet cluster (2-dc cl): Yo, insert hook in next st or sp, yo, draw up a loop, yo, draw yarn through 2 loops on hook, yo, insert hook in same st or sp, yo, draw up a loop, (yo, draw through 2 loops on hook] twice.

3 double crochet cluster (3-dc cl): Yo, insert hook in next st, yo, draw up a loop, yo, draw yarn through 2 loops on hook, [yo, insert hook in same st, yo, draw up a loop, yo, draw through 2 loops on hook] twice, [yo, draw yarn through 2 loops on hook] 3 times.

4 double crochet cluster (4-dc cl): Yo, insert hook in next ch-1 sp, yo, draw up a loop, yo, draw yarn through 2 loops on hook, yo, insert hook in same st or sp, yo, draw up a loop, yo, draw yarn through 2 loops on hook [3 loops on hook], sk the next 2 ch-1 sps, yo, insert hook in the next ch-1 sp, yo, draw up a loop, yo, draw yarn through 2 loops on hook, yo, insert hook in same ch-1 sp, yo, draw up a loop, (yo, draw yarn through 2 loops on hook] twice.

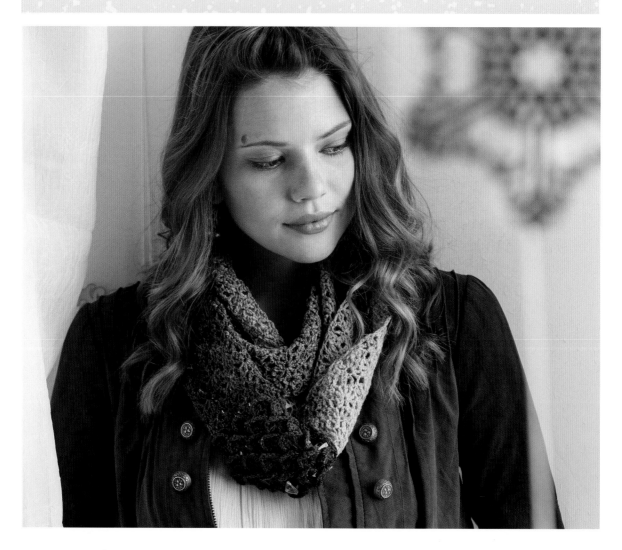

SCARF

Ch 64.

Row 1: Dc in 4th ch from hook and in each ch across, turn—61 dc.

Row 2: Ch 1, sc in first dc, *ch 1, sk the next 4 dc, shell in the next dc, sk the next 4 dc, sc in the next dc; rep from * across, turn—6 shells.

Row 3: Ch 3, 2-dc cl in first sc (counts a 3-dc cl), sk the next ch-1 sp, 2-dc cl in the next ch-1 sp, *ch 3, sc in the next ch-1 sp, ch 1, sc in the next ch-1 sp, ch 3**, 4-dc cl over the next 4ch-1 sps; rep from * across, ending last rep at **, 3-dc cl in last sc, turn—five 4-dc cl.

Row 4: Ch 4 (counts as dc, ch 1), [dc, ch 1] twice in first 3-dc cl (counts as half shell), *sk the next ch-3 sp, sc in the next ch-1 sp, ch 1**, shell in the

⬯ = chain (ch)

• = slip st (sl st)

✛ = single crochet (sc)

Ⳁ = double crochet (dc)

= shell

= 2 double crochet cluster (2-dc cl)

= 3 double crochet cluster (3-dc cl)

= 4 double crochet cluster (4-dc cl)

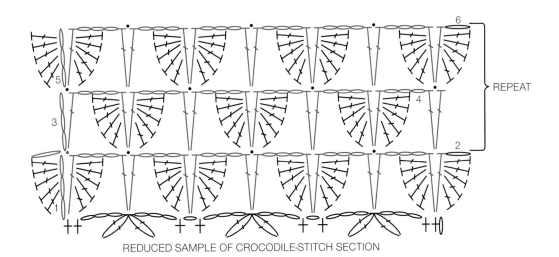

REDUCED SAMPLE OF CROCODILE-STITCH SECTION

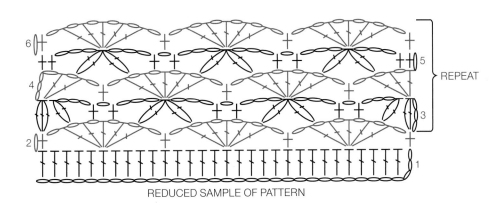

REDUCED SAMPLE OF PATTERN

next 4-dc cl; rep from * across, ending last rep at **, ([dc. ch 1] twice, dc) in last 2-dc cl (counts as half shell), turn—5 shells; 2 half shells.

Row 5: Ch 1, sc in first dc, sc in the next ch-1 sp, *ch 3, 4-dc cl over next 4 ch-1 sps, ch 3, sc in the next ch-1 sp**, ch 1, sc in ch-1 sp; rep from * across, sc in 3rd ch of tch, turn—six 4-dc cl.

Row 6: Ch 1, sc in first sc, *ch 1, shell in the next 4-dc cl, sc in the next ch-1 sp; rep from * across, ending with last sc in last sc, turn.

Rep Rows 2-6 until the piece measures 52" (132 cm) from beg, ending with Row 5 of pattern.

CROCODILE-STITCH SECTION
Row 1: Ch 3 (counts as dc here and throughout), dc in first sc, *ch 3, 2 dc in the next 4-dc cl, ch 3, 2 dc in the next ch-1 sp; rep from * across to last 4-dc cl, ending with 2 dc in last sc, turn—26 dc; 12 ch-3 sps.

Row 2: Ch 1, 5 dc around the post of first dc, rotate to work up side of the next dc, 5 dc around the post of the next dc (scale made), *sl st bet next 2 dc. working over next group of 2 dc, 5 dc around the post of next dc, rotate to work up side of next dc, 5 dc around the post of next dc (scale made); rep from * across, sl st bet last 2 dc, turn—7 scales.

Row 3: Ch 3, dc in same sp bet first 2 dc, *ch 3, 2 dc in the next sl st, ch 3, 2 dc bet 2 dc at center of the next scale; rep from * across, turn—26 dc; 12 ch-3 sps.

Row 4: Sk first pair of 2 dc; working over next group of 2 dc, 5 dc around the post of the next dc, rotate to work up side of the next dc, 5 dc around the post of next dc (scale made), sl st bet the next 2 dc; rep from * across, turn—6 scales.

Row 5: Ch 3, dc in same sp bet first 2 dc, *ch 3, 2 dc bet 2 dc at center of the next scale, ch 3, 2 dc in the next sl st; rep from * across, turn—26 dc; 12 ch-3 sps.

Row 6: Rep Row 2.

Rows 7-18: Rep Rows 3-6 three times. Fasten off.

FINISHING
Sew buttons evenly spaced across the dc edge of the scarf. Use the holes bet sts in the last row of the Crocodile-Stitch Section for buttonholes.

Weave in the ends.

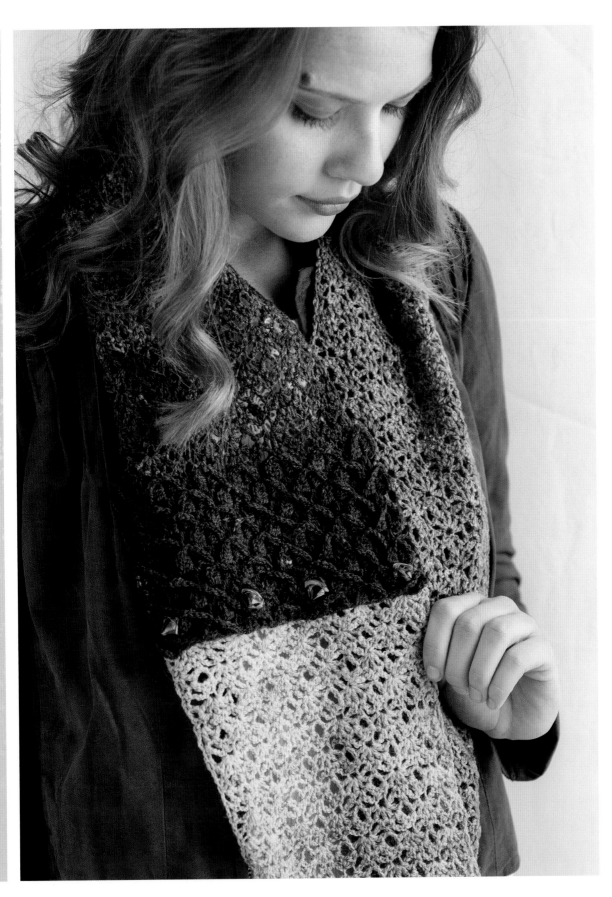

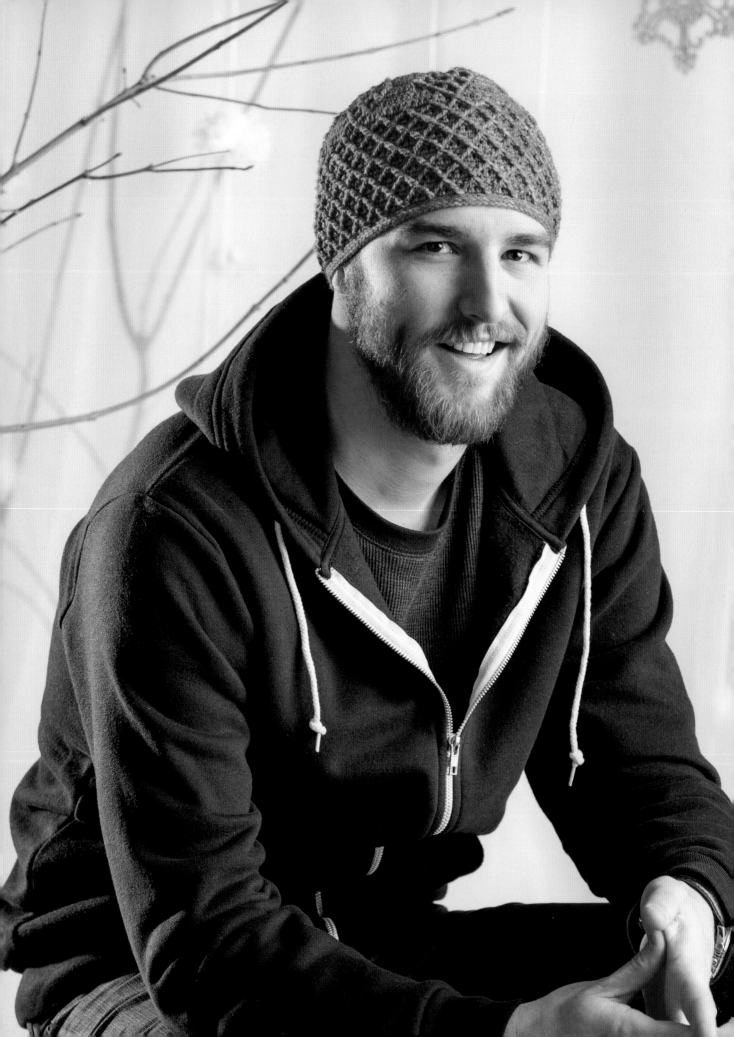

CROSS CREEK HAT

The yarn used in this project is AHHmazingly soft, and the super spin of the fiber makes the post stitches pop off the fabric. Using a semisolid color allows for subtle shades of color without taking away from the stitch pattern.

FINISHED MEASUREMENTS
7¾" (19.5 cm) deep by 20" (51 cm) in circumference.

YARN
DK weight (#3 Light).
Shown here: Grinning Gargoyle Super Twist Sport (80% merino, 10% nylon, 10% cashmere, 250 yd [229 m]/3½ oz [100 g]): Shiny Penny, 1 skein.

HOOK
Size E-4/3.5 mm hook. *Adjust hook size if necessary to obtain the correct gauge.*

NOTIONS
Yarn needle.

GAUGE
16 sts = 3" (7.5 cm); 16 rows = 4" (10 cm).

NOTES

✳ The body of the hat is made in rounds that turn. Always skip a stitch in the current row behind each post st made.

STITCH GUIDE

Front Post treble crochet (FPtr): Yo (twice), insert hook from front to back to front again around the post of the designated st, yo, draw yarn through st [yo, draw through 2 loops on hook] 3 times.

Front Post treble 2 together (FPtrc-2tog): Yo (twice), insert hook from front to back to front again around the post of the designated st 2 rows below and 2 sts to the right, yo, draw through st, yo, [draw through 2 loops on hook] twice, yo (twice), sk the next 3 sts, insert hook from front to back to front again around the post of the next st 2 rows below, yo, draw through st, yo, [draw through 2 loops on hook] 3 times.

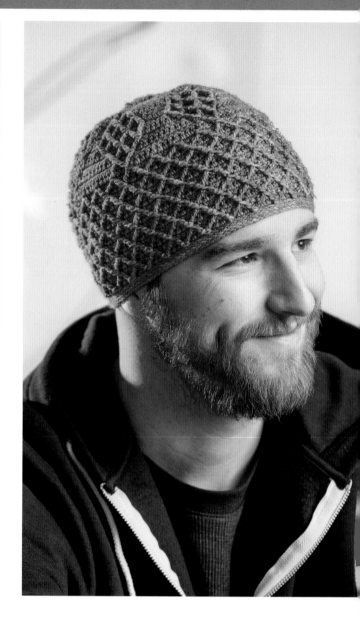

HAT
BRIM

Ch 113.

Row 1: (RS) Working in the back bars of sts, sl st in the 2nd ch from the hook and in each ch across, join with a sl st in the first ch to form a ring—112 sl sts.

Rnds 2–4: (RS) Sl st in the blo of each sl st around.

BODY LATTICE PATTERN

Rnd 1: (RS) Ch 1, sc in each sl st around, join with a sl st in first sc, turn—112 sc.

Rnds 2, 4, and 6: (WS) Ch 2 (does not count as a st here and throughout), dc in each st around, join with a sl st at the top of the beg ch-2 sp, turn—112 dc.

Rnd 3: (RS) Ch 1, sc in the first dc, *FPtr2tog worked in sc sts 2 rnds below**, sc in each of the next 3 dcs; rep from * around, ending last rep at **, sc in each of the last 2 sts, join with a sl st in the first sc, turn—28 FPtr2tog.

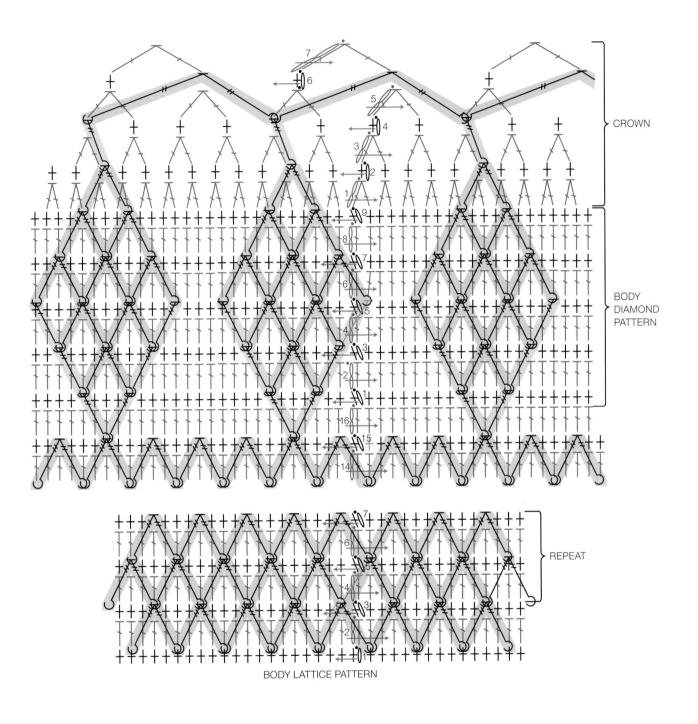

CROWN

BODY
DIAMOND
PATTERN

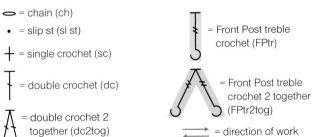

BODY LATTICE PATTERN

REPEAT

⌒ = chain (ch)

• = slip st (sl st)

+ = single crochet (sc)

T = double crochet (dc)

⋀ = double crochet 2
together (dc2tog)

⫯ = Front Post treble
crochet (FPtr)

⋀ = Front Post treble
crochet 2 together
(FPtr2tog)

⇄ = direction of work

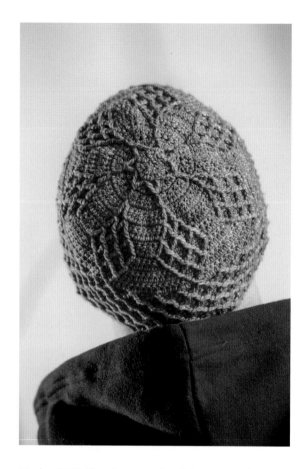

Rnd 3: (RS) Ch 1, *sc in the next dc, FPtr around the post of the next FPtr 2 rows below and to the left of the current st, sc in each of the next 3 dcs, FPtr2tog, sc in each of the next 3 dcs, FPtr around the post of the FPtr 2 rnds below to the right of the current st, sc in each of the next 6 dcs; rep from * around, join with a sl st in the first sc, turn.

Rnd 5: (RS) Ch 1, *sc in each of the next 3 dc, [FPtr2tog, sc in the next 3 dc] twice, FPtr around the post of the FPtr 2 rows below and to the right of the current st, sc in each of the next 3 dc, FPtr around the post of the FPtr 2 rows below and to the left of the current st; rep from * around, join with a sl st in the first sc, turn.

Rnd 7: (RS) Ch 1, *sc in the next dc, [FPtr2tog, sc in each of the next 3 dc] 3 times, sc in each of the next 6 dc; rep from * around, join with a sl st in the first sc, turn.

Rnd 9: (RS) Ch 1, *sc in the next 5 dc, [FPtr2tog, sc in each of the next 3 dc] twice, sc in each of the next 6 dc; rep from * around, join with a sl st in the first sc, turn.

Do not work a dc row.

CROWN

Rnd 1 (dec rnd): (WS) Ch 2 (does not count as a dc here and throughout), *dc2tog over the next 2 sts; rep from * around, join with a sl st in the first dc2tog, turn—56 sts.

Rnd 2: (RS) Ch 1, sc in each of the next 3 dc, FPtr2tog, sc in each of the next 4 dc; rep from * around, join with a sl st in the first sc, turn.

Rnd 3 (dec rnd): (WS) Ch 2, *dc2tog over the next 2 sts; rep from * around, join with a sl st in the first dc2tog, turn—28 sts.

Rnd 4: (RS) Ch 1, *sc in each of the next 2 dc, FPtr around the post of the corresponding FPtr2tog 2 rnds below, sc in the next dc; rep from * around, join with a sl st in the first sc, turn.

Rnd 5 (dec rnd): (WS) Ch 2, *dc2tog over the next 2 sts; rep from * around, join with a sl st in the first dc2tog, turn—14 sts.

Rnd 5: (RS) Ch 1, *sc in each of the next 3 dc, FPtr2tog worked in post sts 2 rnds below; rep from * around, join with a sl st in the first sc, turn.

Rnd 7: (RS) Ch 1, sc in the first dc, *FPtr2tog worked in post sts 2 rnds below**, sc in each of the next 3 dcs; rep from * around, ending last rep at **, sc in each of the last 2 sts, join with a sl st in the first sc, turn.

Rep Rnds 4–7 twice; rep Rnds 4–5 once.

BODY DIAMOND PATTERN

Rnd 1: (RS) Ch 1, *sc in each of the next 3 dcs, FPtr around the post of FPtr2tog 2 rows below and to the left of the current st, sc in each of the next 3 dcs, FPtr around the post of same FPtr2tog as the last FPtr, sc in each of the next 8 dcs; rep from * around, join with a sl st in the first sc, turn—14 FPtr.

Rnds 2, 4, 6, and 8: (WS) Ch 2, dc in each st around, join with a sl st in the top of the beg ch-2 sp, turn—112 dc.

Rnd 6: (RS) Ch 1, *sc in the next dc, FPtr around the post of the corresponding FPtr2tog 2 rnds below; rep from * around, join with a sl st in the first sc, turn.

Rnd 7 (dec rnd): (WS) Ch 2, *dc2tog over the next 2 sts; rep from * around, join with a sl st in the first dc2tog —7 sts. Fasten off, leaving a sewing length of yarn.

FINISHING

Use a sewing length of yarn to sew the top of the crown closed. Weave in the ends.

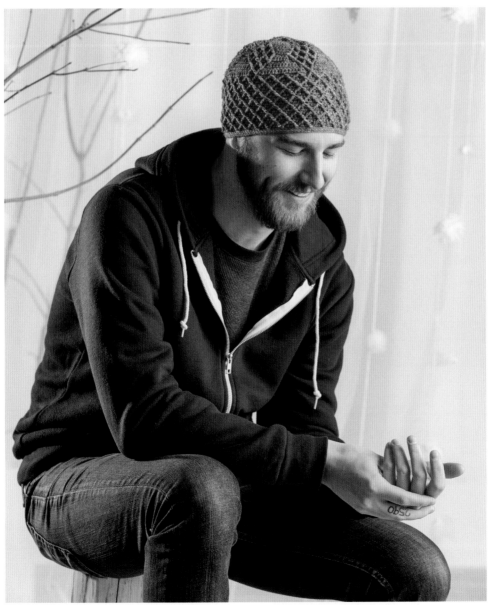

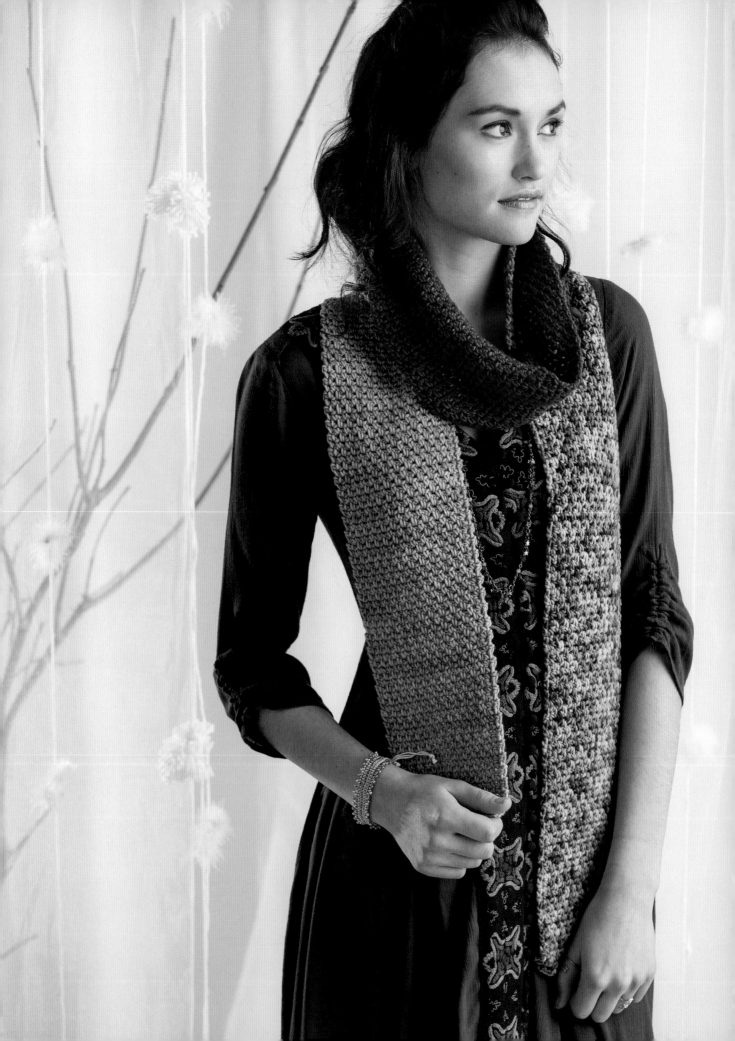

LINEN– STITCH SCARF

Variegated yarn can be difficult to use to show off a stitch pattern. But by adding it as an accent to two semisolid colors and then working linen stitch, the yarn not only shows off the scarf pattern but adds a wow factor.

FINISHED MEASUREMENTS
5" (12.5 cm) wide by 75" (190.5 cm) long.

YARN
Worsted weight (#4 Medium).

Shown here: Malabrigo Merino Worsted (100% merino wool, 210 yd [192 m]/3½ oz [100 g]): CA, #32 Jewel Blue (A), #44 Geronio (B), #206 Velvet Grapes (C), 1 skein each.

HOOK
Size I-9/5.5 mm hook. *Adjust hook size if necessary to obtain the correct gauge.*

NOTION
Yarn needle.

GAUGE
20 sts and 16 rows = 4" (10 cm) in pattern.

STITCH GUIDE

LINEN STITCH
Chain an even number of sts.

Row 1: Sc in 2nd ch from hook, *ch 1, sk next ch, sc in the next ch; rep from * across, turn.

Row 2: Ch 1, sc in first sc, sc in the next ch-1 sp, *ch 1, sc in the next ch-1 sp; rep from * across, sc in last sc, turn.

Row 3: Ch 1, sc in first sc, sk the next sc, *ch 1, sc in the next ch-1 sp; rep from * across, ch 1, sk the next sc, sc in last sc, turn.

Rep Rows 2–3 for pattern.

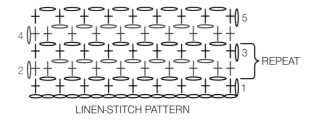

LINEN-STITCH PATTERN

◯ = chain (ch)

+ = single crochet (sc)

SCARF

FIRST SECTION
With A, ch 26.

Row 1: Sc in 2nd ch from hook, *ch 1, sk the next ch, sc in the next ch; rep from * across, turn—12 ch-1 sps.

Work the pattern evenly until the piece measures 25" (63.5 cm) from the beg. Fasten off A, join B.

SECOND SECTION
Work the pattern evenly in the following color sequence: 1 row each of B; C; A; C; B; A; B; C; A; C; B.

THIRD SECTION
Work the pattern evenly with B until the section measures 25" (63.5 cm).

FOURTH SECTION
Work the pattern evenly in the following color sequence: 1 row each of C; A; B; A; C; B; A; C; A; B; A; C.

FIFTH SECTION
Work the pattern evenly with C until the section measures 25" (63.5 cm). Fasten off.

FINISHING
Weave in the ends.

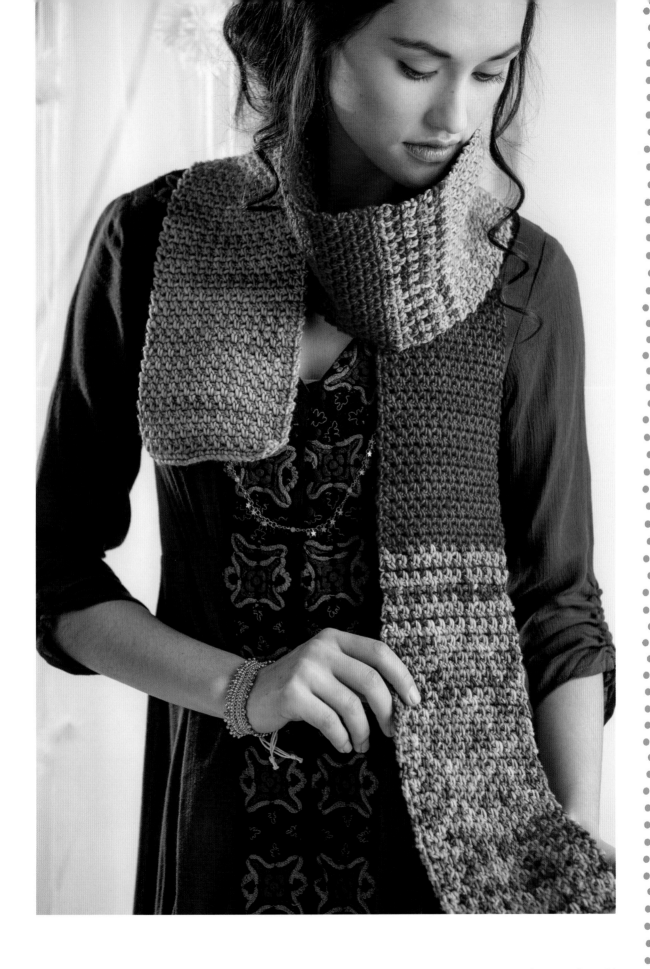

HAT &
CHEVRON
COWL
COORDINATES

The chevron stitches used for this cowl create a dense fabric, so I coupled it with a yarn that is very soft, has a lot of drape, and comes in a wonderful variety of colors. The mix created a visually stunning piece that frames the face beautifully. The coordinating hat uses one color from the cowl in a different stitch pattern so that the set is not matchy-matchy, but still works well together.

FINISHED MEASUREMENTS
Slouchy Hat: 20½" (52 cm) in circumference; 9½" (24 cm) tall.

Cowl: 25" (63.5 cm) in circumference; 10" (25.5 cm) deep.

YARN
Sportweight (#2 Fine).

Shown here: Cascade Sateen (100% acrylic, 300⅕ yd [275 m]/3½ oz [100 g]): Hat: #15 Teal Green, 1 skein. Cowl: #15 Teal Green (A), #26 Aqua (B), #11 Lavender Blue (C), #28 Lake Blue (D), #12 Denim (E), #10 Black Plum (F), #22 Sand (G), 1 skein each.

HOOK
Size F-5/3.75mm hook. *Adjust hook size if necessary to obtain the correct gauge.*

NOTIONS
Yarn needle.

GAUGE
Cowl: 17 sts in pattern (one rep) = 2½" (6.5 cm); 10 rows in pattern = 3" (7.5 cm).

Hat: 2 pattern reps and 10 rows in body pattern = 4" (10 cm).

HAT

BRIM

With A, ch 99, without twisting ch, join with a sl st in first ch to form a ring.

Rnd 1: (RS) Ch 1, sc in each ch around, join with sl st in first sc—99 sc.

Rnds 2–4: Ch 1, *sc in each sc around, join with sl st in first sc—99 sc.

Rnd 5: Ch 1, *sc in each of the next 2 sts, 2 sc in the next st; rep from * around, join with sl st in first sc—132 sc.

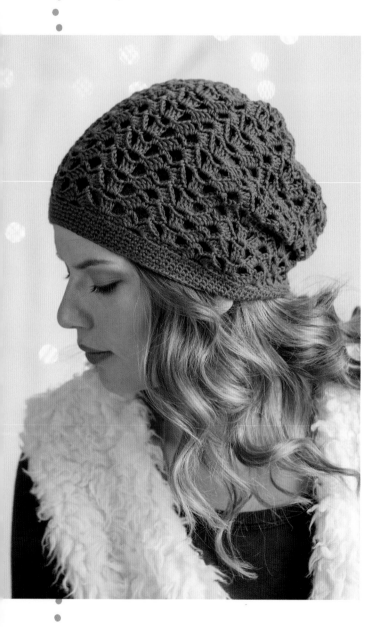

BODY

Rnd 1: Ch 1, *sc in the next st, ch 3, skip the next 3 sts; rep from * around to the last 4 sts, sc in the next st, dc in first sc instead of the last ch-3 sp—33 sc.

Rnd 2: Ch 1, sc around post of the last dc made, ch 2, sc in the next ch-3 sp, (3 dc, ch 3, sc, ch 3, 3 dc) in the next ch-3 sp**, sc in ch-3 sp, ch 2, sc in ch-3 sp; rep from * around, ending last rep at **, join with a sl st in first sc, sl st in the next ch-2 sp—12 shells.

Rnds 4–22: Repeat Rnds 1–2 (9 times); rep Rnd 2 (10 times).

CROWN

Rnd 1: Ch 3, 2 dc in same ch-2 sp, *ch 3, sc in the next ch-3 sp, ch 2, sc in the next ch-3 sp**, ch 3, 3 dc in the next ch-2 sp; rep from * around, ending the last rep at **, dc in top of tch to join.

Rnd 2: Ch 1, sc around the post of the last dc made, *ch 2, sc in the next ch-3 sp, (2 dc, ch 2, sc, ch 2, 2 dc) in the next ch-2 sp, sc in ch-3 sp**, ch 2, sc in the next ch-3 sp; rep from * around, ending the last rep at **, join with a sl st in first sc, sl st in the next ch-2 sp.

Rnd 3: Ch 3, 2 dc in same ch-2 sp, *ch 2, sc in the next ch-3 sp, ch 1, sc in the next ch-3 sp**, ch 2, 3 dc in the next ch-2 sp; rep from * around, ending the last rep at **, hdc in top of tch to join.

Rnd 4: Ch 1, sc around the post of the last hdc made, *ch 2, sc in the next ch-2 sp, ch 2, sc in the next ch-1 sp, ch 2, sc in the next ch-2 sp; rep from * around, join with a sl st in first sc, sl st in the next ch-2 sp.

Rnd 5: Ch 3, 2 dc in same ch-2 sp, *dc2tog over the next 2 ch-2 sps**, 3 dc in the next ch-2 sp; rep from * around, ending the last rep at **, join with a sl st in top of tch.

Rnd 6: Ch 1, sc in first st, *ch 1, sk the next st, sc in the next st; rep from * around to the last st, ch 1, join with a sl st in first sc, sl st in the next ch-1 sp.

Rnd 7: Ch 1, *sc2tog over the next 2 ch-1 sps; rep from * around, join with a sl st in first sc2tog. Fasten off, leaving a sewing length of yarn.

FINISHING

With a yarn needle, weave the sewing length of yarn through the front loops only of the remaining sts, then carefully pull the stitches snug to close the hole at the top of the crown. Thread the needle on the inside of the hat and weave in the ends.

BOTTOM EDGING

Join the yarn with a sl st to the foundation edge of the brim, ch 1, sc in each st around, join with a sl st in the first sc. Fasten off. Weave in the ends.

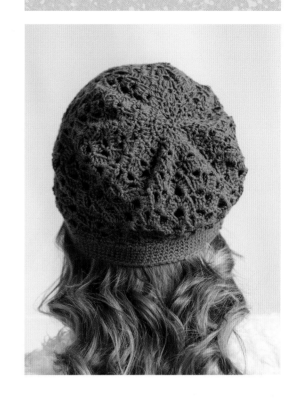

= chain (ch)

• = slip st (sl st)

= single crochet (sc)

= half double crochet (hdc)

= double crochet (dc)

= single crochet 2 together (sc2tog)

= double crochet 2 together (dc2tog)

= worked in back loop only

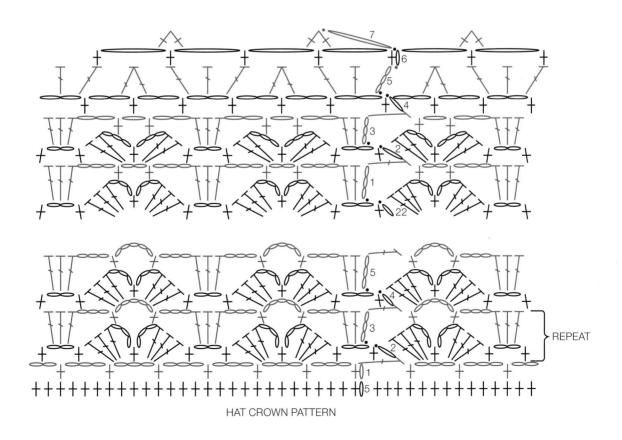

HAT CROWN PATTERN

COWL

COLOR SEQUENCE

Work in the following color sequence: 2 rows each of A, B, C, D, E, F, G; rep from * throughout.

With A, ch 71.

Note: Work in back loop only throughout.

Row 1: (RS) Dc in 4th ch from hook (beg ch-3 counts as dc), 2 dc in each of the next 2 ch, [skip the next ch, dc in the next ch] 5 times, *sk the next ch, 2 dc in each of the next 6 ch, [sk the next ch, dc in the next ch] 5 times; rep from * across to the last 4 ch, sk the next ch, 2 dc in each of the last 3 ch, turn—68 dc.

Row 2: (WS) Ch 1, sc in each dc across, turn—68 sc. Fasten off A, join B.

Rnd 3: With B, ch 3 (counts as dc here and throughout), dc in first sc, 2 dc in each of the next 2 sc, [sk the next sc, dc in next sc] 5 times, *sk the next sc, 2 dc in each of the next 6 sc, [sk the next sc, dc in the next sc] 5 times; rep from * across to the last 4 sc, sk the next sc, 2 dc in each of the last 3 sc, turn.

Row 4: Ch 1, sc in each dc across, turn. Fasten off B, join C.

Continuing in color sequence as established, rep Rows 2 and 3 for pattern until 84 rows have been completed (6 reps of color sequence). Do not fasten off.

FINISHING

Fold Cowl in half with RS together, with G, matching sts, working through double thickness of the last row and foundation ch, sl st in each st across. Fasten off. Weave in the ends.

⊖ = chain (ch)

• = slip st (sl st)

+ = single crochet (sc)

T = half double crochet (hdc)

⊤ = double crochet (dc)

⋏ = single crochet 2 together (sc2tog)

⋀ = double crochet 2 together (dc2tog)

⌒ = worked in back loop only

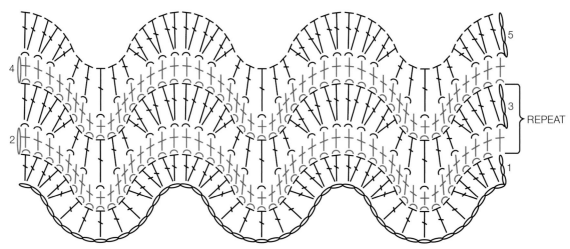

REDUCED SAMPLE OF COWL PATTERN

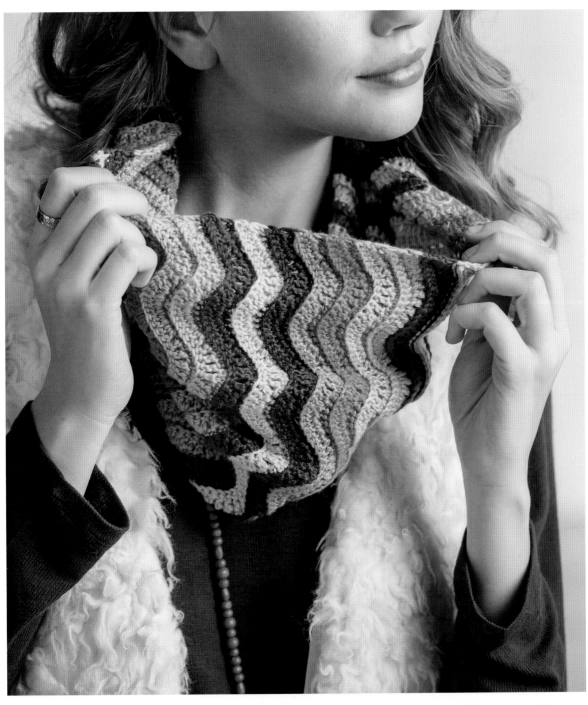

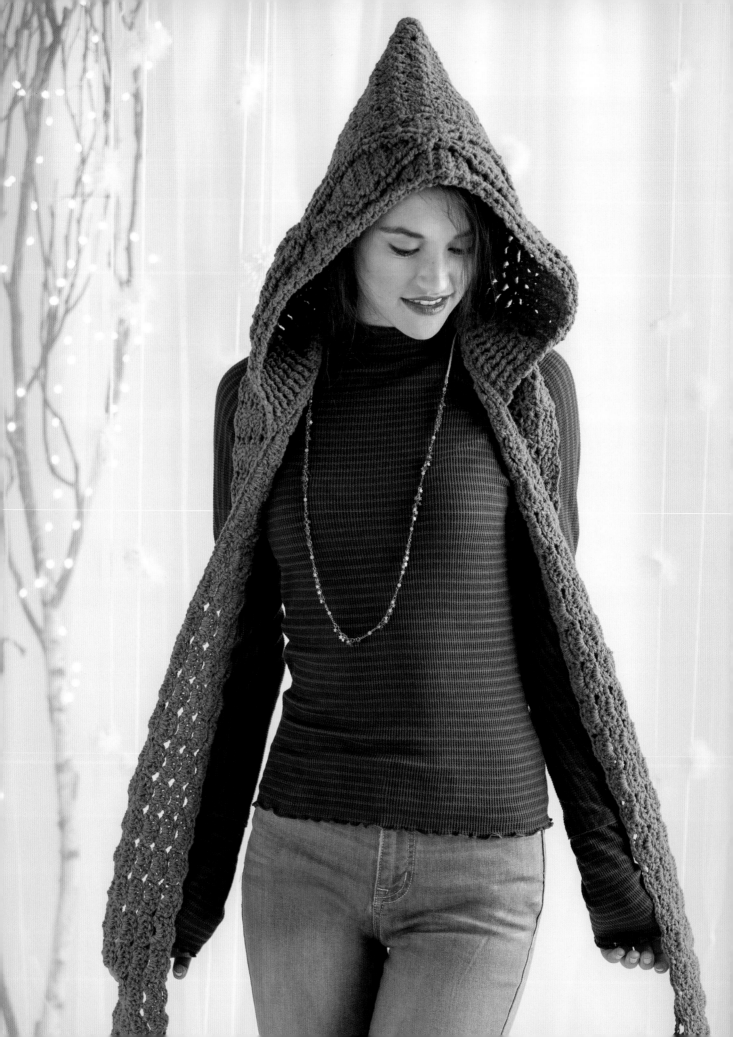

GREEN MOUNTAIN SPINNERY HOODED SCARF

Look fashionable and fabulous in this hooded scarf. The yarn used is a woolen-spun yarn that has a nice crispness to it, so the crochet cables around the face really pop. The body of the hood and scarf uses a shell stitch that complements the cables perfectly and adds a bit of softness to the crisp cables.

SIZE
Women's One Size

FINISHED MEASUREMENTS
Length of front to back seam: 10½" (26.5 cm).
Length of back seam: 15" (38 cm).
Length of scarf: 29" (73.5 cm) from hood on each side.
Width of scarf: 4½" (11.5 cm).

YARN
Worsted weight (#4 Medium).
Shown here: Green Mountain Spinnery Weekend Wool (100% American Wool, 140 yd [128 m], 3½ oz [100 g]): #7760 Lichen, 5 hanks.

HOOKS
Sizes G-6 (4 mm) and I-9 (5.5 mm) hooks. *Adjust hook size if necessary to obtain the correct gauge.*

NOTIONS
Yarn needle.

GAUGE
Cable Band: With smaller hook, 17 sts and 10 rows in pattern = 4" (10 cm).
Hood: With smaller hook, 3 shells and 10 rows in pattern = 3½" (9 cm).
Scarf: With larger hook, 2 shells and 8 rows = 3" (7.5 cm) in pattern.

NOTES

❊ The cabled band is made first, then stitches are added to one of the long sides to make the hood. Then stitches are worked along the bottom edge of the hood and band to create the scarf. Skip stitch behind each post st made.

STITCH GUIDE

Front Post double crochet (FPdc): Yo, insert hook from front to back to front again around the post of the next st, yo, draw yarn through st, [yo, draw yarn through 2 loops on hook] twice.

Back Post double crochet (BPdc): Yo, insert hook from back to front to back again around the post of the next st, yo, draw yarn through st, [yo, draw yarn through 2 loops on hook] twice.

Front Post treble crochet (FPtr): Yo (twice), insert hook from front to back to front again around the post of the next st, yo, draw yarn through st, [yo, draw yarn through 2 loops on hook] 3 times.

Back Post treble crochet (BPtr): Yo, insert hook from back to front to back again around the post of the next st, yo, draw yarn through st, [yo, draw yarn through 2 loops on hook] 3 times.

C5L: Sk the next 3 sts, FPtr around the post of each of the next 2 sts, working behind post sts just made, dc in 3rd skipped st, working in front of sts just made, FPtr around the post of each of the first 2 skipped sts.

C3R: Sk the next st, FPtr around the post of each of the next 2 sts, working behind post sts just made, tr in the last skipped st,

C3L: Sk the next 2 sts, tr in the next st, working in front of st just made, FPtr around the post of each of the last 2 skipped sts.

BAND

FIRST END

Ch 19.

Row 1 (set-up row): Dc in 3rd ch from hook (beg ch 2 does not count as a st) and in each ch across, turn—17 dc.

Row 2: (RS) Ch 2 (does not count as a st here and throughout), hdc in the first dc, *FPdc around the next st, BPdc around the next st; rep from * to the last stitch, hdc, turn—2 hdc, 8 FPdc, 7 BPdc.

Row 3: (WS) Ch 2, hdc in the first hdc, *BPdc around the post of the next st, FPdc around the post of the next st; rep from * across to the last st, hdc in the the last st, turn—2 hdc, 8 BPdc, 7 FPdc.

Repeat Rows 2 and 3 twice.

BEGIN CABLE

Row 1: (RS) Ch 2, hdc in the the first hdc, FPdc around the post of the next st, dc in each of the next 4 sts, sk the next 3 sts, C5R, dc in each of the the next 4 sts, FPdc around the post of the next st, hdc in the the last st, turn.

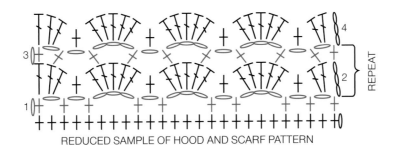

REDUCED SAMPLE OF HOOD AND SCARF PATTERN

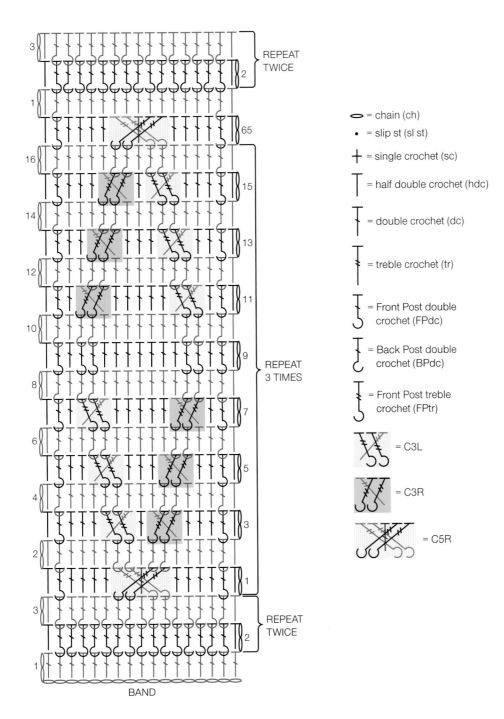

○ = chain (ch)

• = slip st (sl st)

+ = single crochet (sc)

T = half double crochet (hdc)

= double crochet (dc)

= treble crochet (tr)

= Front Post double crochet (FPdc)

= Back Post double crochet (BPdc)

= Front Post treble crochet (FPtr)

= C3L

= C3R

= C5R

BAND

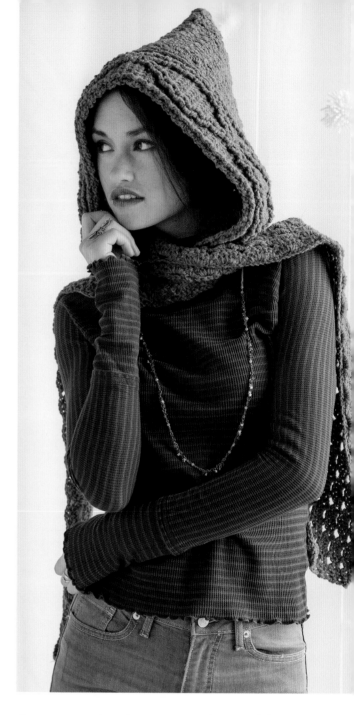

Row 2: Ch 2, hdc in the the first hdc, BPdc around the post of the next st, dc in each of the next 4 sts, BPtr around the post of each of the next 2 sts, dc in the next st, BPtr around the post of each of the next 2 sts, dc in each of the next 4 sts, BPdc around the post of the next st, hdc in the last st, turn.

Row 3: Ch 2, hdc in the first hdc, FPdc around the post of the next st, dc in each of the next 3 sts, C3R, dc in the next st, C3L, dc in each of the next 3 sts, FPdc around the post of the next st, hdc in the last st, turn.

Row 4: Ch 2, hdc in the first hdc, BPdc around the post of the next st, dc in each of the next 3 sts, BPtr around the post of each of the next 2 sts, dc in each of the next 3 sts, BPtr around the post of each of the next 2 sts, dc in each of the last 3 sts, BPdc around the post of the next st, hdc in the last st, turn.

Row 5: Ch 2, hdc in the first hdc, FPdc around the post of the next st, dc in each of the next 2 sts, C3R, dc in each of the next 3 st, C3L, dc in each of the next 2 sts, FPdc around the post of the next st, hdc in the last st, turn.

Row 6: Ch 2, hdc in the first hdc, BPdc around the post of the next st, dc in each of the next 2 sts, BPtr around the post of each of the next 2 sts, dc in each of the next 5 sts, BPtr around the post of each of the next 2 sts, dc in each of the next 2 sts, BPdc around the post of the next st, hdc in the last st, turn.

Row 7: Ch 2, hdc in the first hdc, FPdc around the post of the next st, dc in the next st, C3R, dc in each of the next 5 sts, C3L, dc in the next st, FPdc around the post of the next st, hdc in the last st, turn.

Row 8: Ch 2, hdc in the first hdc, BPdc around the post of the next st, dc in the next st, BPtr around the post of each of the next 2 sts, dc in each of the next 7 sts, BPtr around the post of each of the next 2 sts, dc in the next st, BPdc around the post of the next st, hdc in the last st, turn.

Row 9: Ch 2, hdc in the first hdc, FPdc around the post of the next st, dc in the next st, FPtr around the post of each of the next 2 sts, dc in each of the next 7 sts, FPtr around the post of each of

the next 2 sts, dc in the next st, FPdc around the post of the next st, hdc in the last st, turn.

Row 10: Ch 2, hdc in the first hdc, BPdc around the post of the next st, dc in the next st, BPtr around the post of each of the next 2 sts, dc in each of the next 7 sts, BPtr around the post of each of the next 2 sts, dc in the next st, BPdc around the post of the next st, hdc in the last st, turn.

Row 11: Ch 2, hdc in the first hdc, FPdc around the post of the next st, dc in the next st, C3L, dc in each of the next 5 sts, C3R, FPdc around the post of the next st, hdc in the last st, turn.

Row 12: Ch 2, hdc in the first hdc, BPdc around the post of the next st, dc in each of the next 2 sts, BPtr around the post of each of the next 2 sts, dc in each of the next 5 sts, BPtr around the post of each of the next 2 sts, dc in each of the next 2 sts, BPdc around the post of the next st, hdc in the last st, turn.

Row 13: Ch 2, hdc in the first hdc, FPdc around the post of the next st, dc in each of the next 2 sts, C3L, dc in each of the next 3 sts, C3R, dc in each of the next 2 sts, FPdc around the post of the next st, hdc in the last st, turn.

Row 14: Ch 2, hdc in the first hdc, BPdc around the post of the next st, dc in each of the next 3 sts, BPtr around the post of each of the next 2 sts, dc in each of the next 3 sts, BPtr around the post of each of the next 2 sts, dc in each of the next 3 sts, BPdc around the post of the next st, hdc in the last st, turn.

Row 15: Ch 2, hdc in the first hdc, FPdc around the post of the next st, dc in each of the next 3 sts, C3L, dc in the next st, C3R, dc in each of the next 3 sts, FPdc around the post of the next st, hdc in the last st, turn.

Row 16: Ch 2, hdc in the first hdc, BPdc around the post of the next st, dc in each of the next 4 sts, BPtr around the post of each of the next 2 sts, dc in the next st, BPtr around the post of each of the next 2 sts, dc in each of the next 4 sts, BPdc around the post of the next st, hdc in the last st, turn.

Rep Rows 1–16 three times.

Rep Cable Row 1 once.

SECOND END

Row 1 (set-up row): Ch 2, hdc in the first hdc, BPdc around the post of the next st, dc in each of the next 13 sts across, BPdc around the post of the next st, hdc in the last st, turn—13 dc.

Row 2: (RS) Ch 2, hdc in the first hdc, *FPdc around the post of the next st, BPdc around the post of the next st; rep from * across to the last st, hdc in the last st, turn—2 hdc, 8 FPdc, 7 BPdc.

Row 3: (WS) Ch 2, hdc in the first hdc, *BPdc around the post of the next st, FPdc around the

post of the next st; rep from * across to the last st, hdc in the last st, turn—2 hdc, 8 BPdc, 7 FPdc.

Rep Rows 2 and 3 twice. Do not fasten off.

HOOD
Set-up Row: With RS facing, working across side edge of Band, ch 1, work 157 sc, turn—157 sc.

Row 1: (WS) Ch 1, sc in the first sc, ch 1, sk the next sc, sc in the next sc, *ch 1, sk the next sc, sc in the next sc, ch 3, sk the next 3 sc, sc in the next sc; rep from * across to the last 4 sts, [ch 1, sk the next sc, sc in the next sc] twice, turn—25 ch-3 sps.

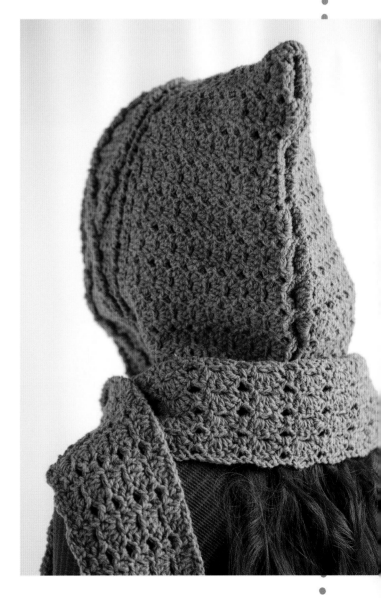

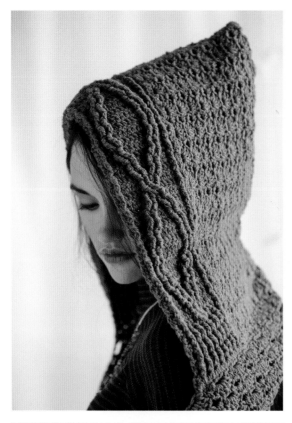

Row 2: (RS) Ch 3 (counts as dc here and throughout), 2 dc in the next ch-1 sp, *sc in the next ch-1 sp, 5 dc in the next ch-3 sp; rep from * across to the last 2 ch-1 sps, sc in the next ch-1 sp, 2 dc in the next ch-1 sp, dc in the last sc, turn—25 shells.

Row 3: (WS) Ch 1, sc in the first dc, ch 1, sc in the next dc, *ch 1, sk the next 3 sts, sc in the next dc**, ch 3, sk the next st, sc in the next dc; rep from * across, ending the last rep at **, ch 1, sc in top of tch, turn.

Repeat Rows 2 and 3 nine times.

FIRST FINISHING
Fold the hood with RS facing and seam the last row completed. Fasten off.

SCARF
Ch 110, with the RS of Hood facing, starting in the first st of Band, working along the bottom edge of Hood, work 87 sc evenly spaced across, ending in the last st of Band, ch 111.

Row 1: (WS) Sc in 2nd ch from hook, ch 1, sk the next ch, sc in the next ch, *ch 1, sk the next st, sc in the next st, ch 3, sk the next 3 sts, sc in the next st; rep from * across to the last 4 ch on other end of Scarf, [ch 1, sk the next ch, sc in the next ch] twice, turn—50 ch-3 sps.

Row 2: (RS) Ch 3, 2 dc in the first ch-1 sp, *sc in the next ch-1 sp, 5 dc in the next ch-3 sp; rep from * across to the last 2 ch-1 sps, sc in the next ch-1 sp, 2 dc in the next ch-1 sp, dc in the last sc, turn—50 shells.

Row 3: (WS) Ch 1, sc in the first dc, ch 1, sc in the next dc, *ch 1, sk the next 3 sts, sc in the next dc**, ch 3, sk the next st, sc in the next dc; rep from * across, ending the last rep at **, ch 1, sc in top of tch, turn.

Rep Rows 2 and 3 four times. Fasten off.

Weave in the ends.

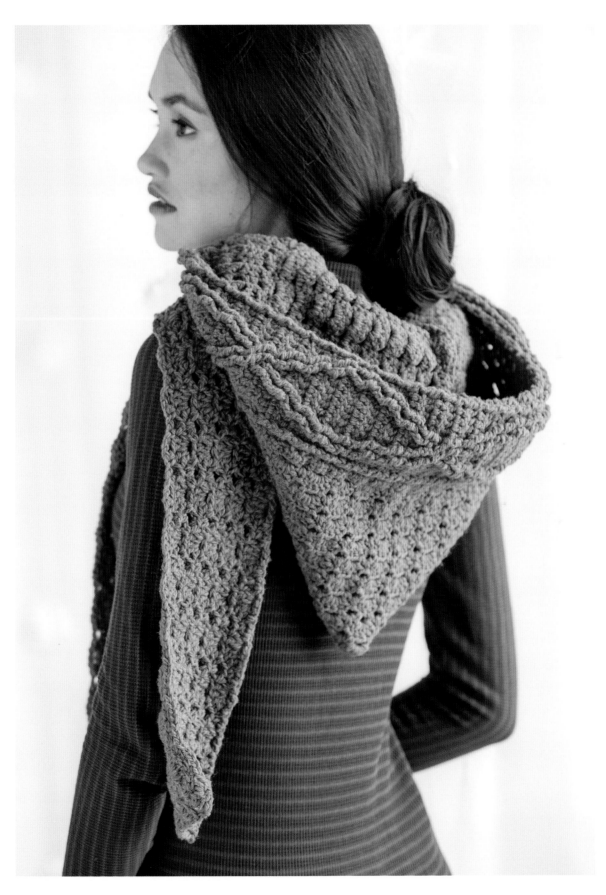

BIG PINK HAT

This is one of my favorite designs because of the simple construction, simple stitches, bulky and bright yarn, and the speed of the project. The hat is fun and fast!

FINISHED MEASUREMENTS
22½" (57 cm) in circumference; 10" (25.5 cm) tall.

YARN
Chunky weight (#5 Bulky).
Shown here: Patons Classic Wool Bulky (100% wool, 78 yd [71 m]/3½ oz [100 g]): Deep Blush (A), 2 skeins and Spring Green (B), 1 skein.

HOOK
Size K-10½/6.5 mm hook. Adjust the hook size if necessary to obtain the correct gauge.

NOTIONS
Yarn needle.

GAUGE
10 sts and 6 rows in pattern = 4" (10 cm).

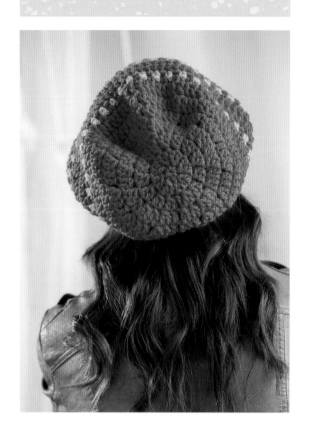

HAT

BRIM

With A, ch 56; without twisting ch, join with a sl st in the first ch to form a ring.

Rnd 1: (RS) Ch 3 (counts as dc here and throughout), dc in each ch around, join with sl st in 3rd ch of beg ch-3—56 dc.

BODY

Rnd 2: Ch 1, *sc in each of the next 3 sts, 2 sc in the next st; rep from * around, join with a sl st in the first sc—70 sc.

Rnd 3: Ch 3, dc in each sc around, join with a sl st in the 3rd ch of the beg ch—70 dcs. Drop A to WS to be picked up later, join B.

Rnd 4: Ch 1. Starting in first st, *sc in dc, ch 1, sk the next st; rep from * around, join with a sl st in the first sc—35 ch-1 sps. Fasten off B, pick up A.

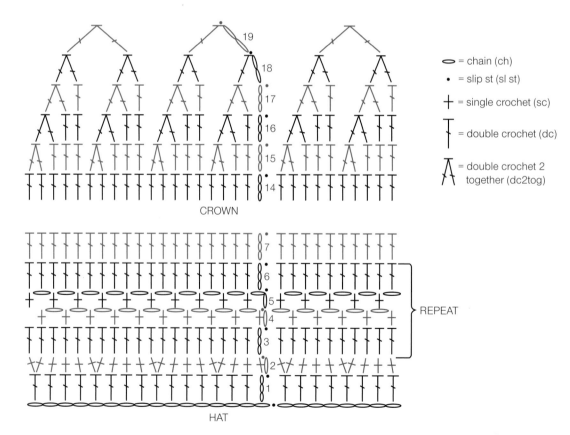

⬮ = chain (ch)

• = slip st (sl st)

+ = single crochet (sc)

T = double crochet (dc)

⋀ = double crochet 2 together (dc2tog)

CROWN

REPEAT

HAT

Rnd 5: With A, ch 2 (counts as sc, ch 1), sc in ch-1 sp, *ch 1, sc in the next ch-1 sp; rep from * around to the last sc, join with a sl st in 2nd ch of beg ch-2—35 ch-1 sps.

Rnd 6: Ch 3, dc in each sc and ch-1 sp around, join with a sl st in 3rd ch of beg ch-3—70 dc.

Rnds 7–14: Rep Rnds 3–6 twice.

CROWN

Rnd 15: Ch 3, dc in each of the next 2 sts, dc2tog over the next 2 sts, *dc in each of the next 3 sts, dc2tog over the next 2 sts; rep from * around, join with a sl st in the 3rd ch of beg ch-3—56 dc.

Rnd 16: Ch 3, dc in the next st, dc2tog over the next 2 sts, *dc in each of the next 2 sts, dc2tog over the next 2 sts; rep from * around, join with a sl st in the 3rd ch of beg ch-3—42 dc.

Rnd 17: Ch 3, dc2tog over the next 2 sts, *dc in the next st, dc2tog over the next 2 sts; rep from * around, join with a sl st in the 3rd ch of beg ch-3—28 dc.

Rnd 18: Ch 2, dc in the next st (counts as first dc2tog), *dc2tog over the next 2 sts; rep from * around, join with a sl st in the first dc—14 sts.

Rnd 19: Rep Rnd 18—7 sts. Fasten off, leaving a sewing length of yarn.

FINISHING

Using a yarn needle, weave the sewing length of yarn through the front loops only of the remaining sts. Carefully pull the stitches snug to close the hole at the top of the crown. Thread the needle on the inside of the hat and weave in the ends.

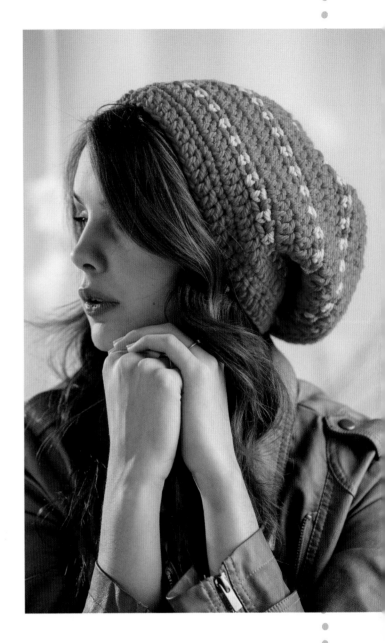

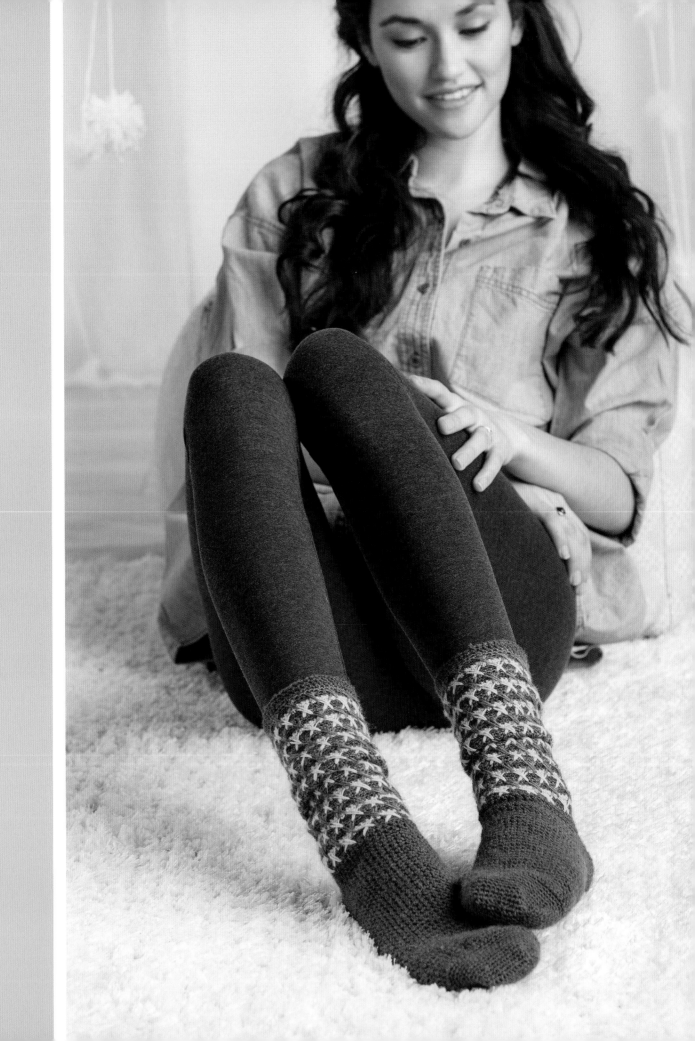

NEW FAVORITE
SOCKS

A cup of cocoa, a roaring fire, and a cozy pair of socks . . . what can get better in the middle of winter? Classic toe-up sock construction is paired up with a colorful pattern stitch on the leg and makes for a completely customizable sock.

FINISHED MEASUREMENTS
8½ (9, 9¾, 10¼)" (21.5 [23, 25, 26] cm) long.

Directions are given for women's shoe size Small. Changes for Medium, Large, and XL are in parentheses.

YARN
Fingering weight (#1 Super Fine).

Shown here: Premier Deborah Norville Serenity Sock Weight Solids (50% merino, 25% nylon, 25% rayon; 230 yd/1¾ oz [50 g]): #5007 Woodsy Green (A), 2 skeins; #5004 Purple and #5008 Hot Line, 1 skein each.

HOOK
Size D/3.25mm hook. *Adjust hook size if necessary to obtain the correct gauge.*

NOTIONS
2 stitch markers; tapestry needle.

GAUGE
22 sts and 20 rows in exsc = 4" (10 cm); 13 sts and 19 rows = 2" (5 cm) in leg pattern after blocking.

NOTES

❋ Sock is made from the toe up.

❋ Markers are used to help distinguish the beginning of each round being worked. Place a stitch marker or 2" (5 cm) scrap piece of yarn before the first stitch of each round, moving the marker up to the next round after each round is complete.

STITCH GUIDE

Extended single crochet (exsc): Insert hook in the next st, yo, draw up a loop, yo, draw through one loop on the hook, yo, draw through 2 loops on the hook.

Long single crochet (Lsc): Working around the previous 2 rows, insert the hook from front to back in the designated st 3 rows below, yo, draw up a loop to the level of the current row, yo, draw the yarn through 2 loops on the hook.

SOCKS (MAKE 2)
TOE
With A, ch 11 (13, 17, 21).

Rnd 1: Sc in 2nd ch from the hook and in each ch across, place marker in the last sc made to mark the side; working in the free loops of the beginning ch, sc in each of the first 10 (12, 16, 20) chs, place marker in the last sc made to mark side; do not join, place marker to mark the beginning of the round—20 (24, 32, 40) sc.

Rnd 2 (inc rnd): *2 sc in the next sc, sc in each sc across to within one sc of the next marked sc, 2 sc in the next sc, sc in marked sc (move marker to sc just made); rep from * once—24 (28, 36, 44) sc.

Rnd 3: *Sc in each sc across to the marked sc, sc in the marked sc (move marker to sc just made); rep from * once.

Rnds 4–11: Rep Rnds 2–3 four times—40 (44, 52, 56) sc at the end of the last rnd. Remove the side markers at the end of the last rnd. Continue to use a marker at the beg of each rnd.

FOOT
Rnd 1: Exsc in each st around.

Repeat Rnd 1 for pattern until Toe and Foot measure 6½ (7, 7¾, 8¼)" (16.5 [18, 19.5, 21] cm) from beginning ch or to desired length from the tip of the toe to the ankle bone.

Remove the marker.

HEEL
Begin working in rows.

Row 1: (RS) Sc in each of the next 24 (26, 32, 36) sc, turn.

Row 2: (WS) Ch 1, sc in each sc across, turn—24 (26, 32, 36) sc.

Rows 3–14: Ch 1, sc in each sc across to the last sc, turn, leaving last sc unworked—12 (14, 20, 24) sc.

Row 15: Ch 1, sc in each sc across, turn—12 (14, 20, 24) sc.

Row 16: Ch 1, sc in each sc across, sc in the next unworked sc on the row below (row 14), sl st in the end of the same row, turn—13 (15, 21, 25) sc.

Rows 17–27: Sk the first sl st, sc in each sc across, sc in the next unworked sc in the row below, sl st in the end of the same row, turn—24 (26, 32, 36) sc at the end of the last row. Do not turn at the end of the last rnd.

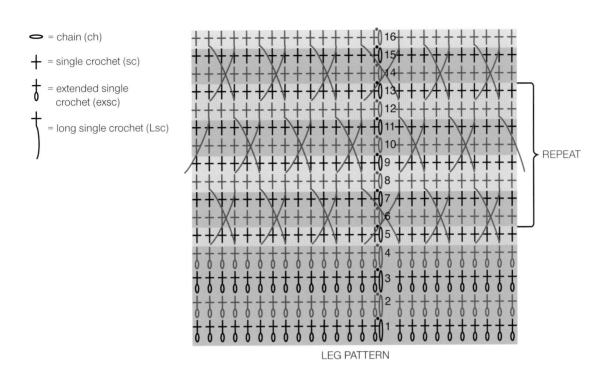

= chain (ch)

+ = single crochet (sc)

= extended single crochet (exsc)

= long single crochet (Lsc)

REPEAT

LEG PATTERN

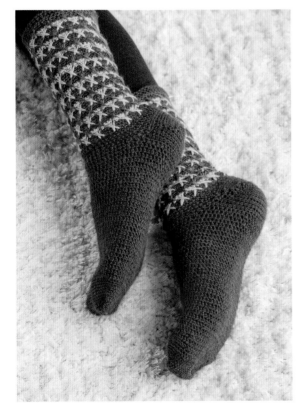
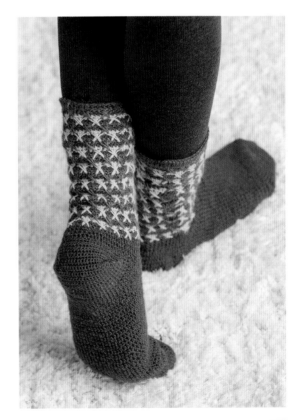

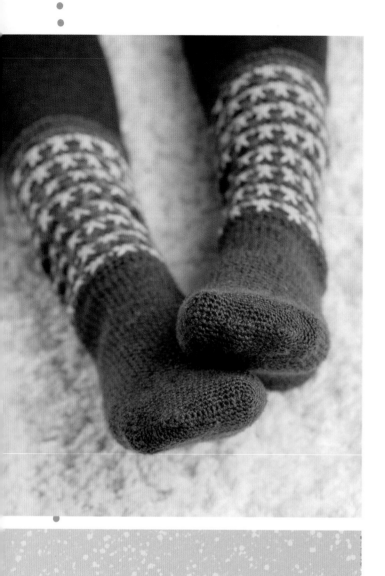

LEG

Begin working in rnds.

Rnd 1: (RS) Working in sts around the Foot and Heel, work 40 (48, 52, 56) exsc evenly spaced around, join with a sl st in the first exsc, place a marker to mark the beginning of the round—40 (48, 52 56) exsc, do not turn.

Rnds 2–4: With A, ch 1, exsc in each st around, join with a sl st in the first exsc. Drop A to WS to be picked up later; join B.

Rnd 5: With B, ch 1, sc in each st around, join with a sl st in the first sc. Drop B to WS to be picked up later; pick up A.

Rnds 6–7: With A, ch 1, sc in each st around, join with a sl st in the first sc. Drop B to WS to be picked up later; join C.

Rnd 8: With C, ch 1, sc in the first sc, Lsc in the sc 2 sts back and 3 rows below, *sc in the next sc, sk next 2 sc, Lsc in next sc 3 rows below, sc in next sc, Lsc in sc 3 rows below first skipped sc; rep from * around to the last 2 sts, sc in the next st, sc in the sc 3 rows below; first Lsc made in the rnd, join with a sl st in the first sc.

Rnd 9: Ch 1, sc in each st around, join with a sl st in the first sc. Drop C to WS to be picked up later; pick up A.

Rnds 10–11: With A, ch 1, sc in each st around, join with a sl st in the first sc. Drop A to WS to be picked up later; pick up B.

Rnd 12: With B, *sc in sc, skip next 2 sc, Lsc in the next sc 3 rows below, sc in the next sc, Lsc in the sc 3 rows below the first skipped sc; rep from * around, join with a sl st in the first sc.

Rnd 13: Ch 1, sc in each st around, join with a sl st in the first sc.

Rnds 14–69: Rep Rnds 6–13 seven times, or to the desired length, ending with Row 13 of the pattern.

Next Rnd: Ch 1, exsc in each st around, join with a sl st in first exsc.

Next Rnd: Rep last rnd. Fasten off. Weave in ends.

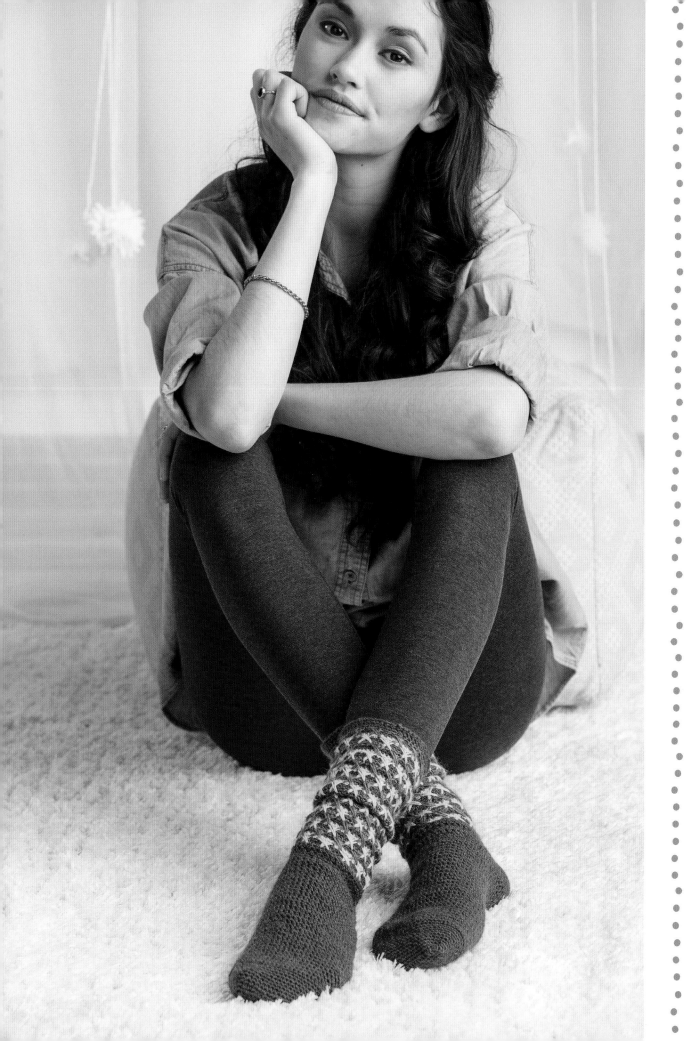

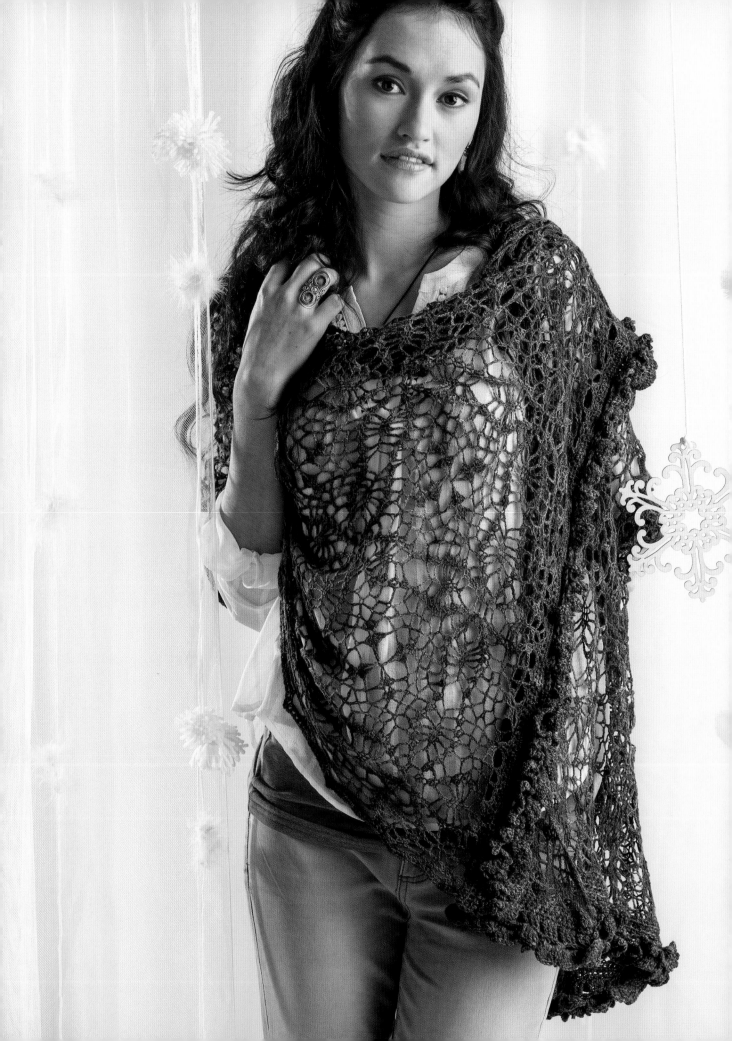

LACE MOTIF WRAP

Lace yarn is not just for knitters. This wrap demonstrates how a beautiful hand-dyed yarn crocheted in lacey motifs can turn a simple wrap into a stunning fashion piece. The motifs are joined as you go, and the subtle ruffled edge adds a bit of weight to help open up the fabric as the wrap lays across the shoulders.

FINISHED MEASUREMENTS
28" (71 cm) by 63" (160 cm).

YARN
Laceweight (#2 Fine).
Shown here: Black Bunny Fibers Handpainted Merino Laceweight (100% merino, 880 yd [805 m]/3½ oz [100 g]): Blue Bird, 3 hanks.

HOOK
Size H-8/5 mm hook. *Adjust hook size if necessary to obtain the correct gauge.*

NOTIONS
Yarn needle.

GAUGE
First 2 rnds of Motif = 2½" (6.5 cm) in diameter unblocked: Motif = 6" (15 cm) unblocked; Motif = 7" (18 cm) blocked.

LACE MOTIF
FIRST MOTIF

Ch 6, join with a sl st in first ch to form a ring.

Rnd 1: Ch 3 (counts as dc here and throughout), 2 dc in ring, ch 3, *3 dc in ring, ch 3; rep from * around, join with a sl st in top of beg ch-3 sp—12 dc; 4 ch-3 sps.

Rnd 2: Ch 3, 2 dc in same st, *ch 3, sk the next dc, 3 dc in the next dc, ch 7**, 3 dc in the next dc; rep from * around, ending last rep at **, join with a sl st in top of beg ch-3 sp—24 dc; 4 ch-3 sps; 4 ch-7 sps.

Rnd 3: Sl st in the next dc, ch 3, 2 dc in same st, *ch 3, sk the next 2 dc, 3 dc in the next dc, ch 4, sc in the next ch-7 sp, ch 4, sk the next dc**, 3 dc in the next dc; rep from * around, ending last rep at **, join with a sl st in top of beg ch-3 sp.

Rnd 4: Sl st in the next dc, ch 3, 2 dc in same st, *ch 5, sk the next 2 dc, 3 dc in the next dc, ch 3, sc in the next ch-4 sp, sc in the next sc, sc in the next

= chain (ch)
• = slip st (sl st)
+ = single crochet (sc)
= double crochet (dc)
= treble crochet (tr)
⌢ = worked in back loop only
⌣ = worked in front loop only

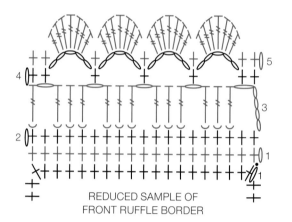

REDUCED SAMPLE OF
FRONT RUFFLE BORDER

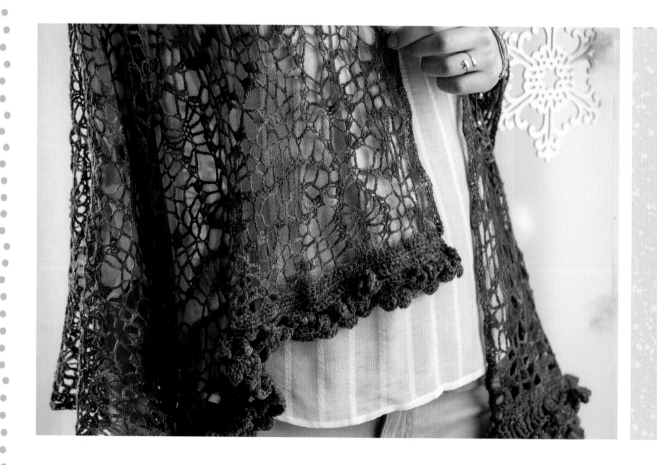

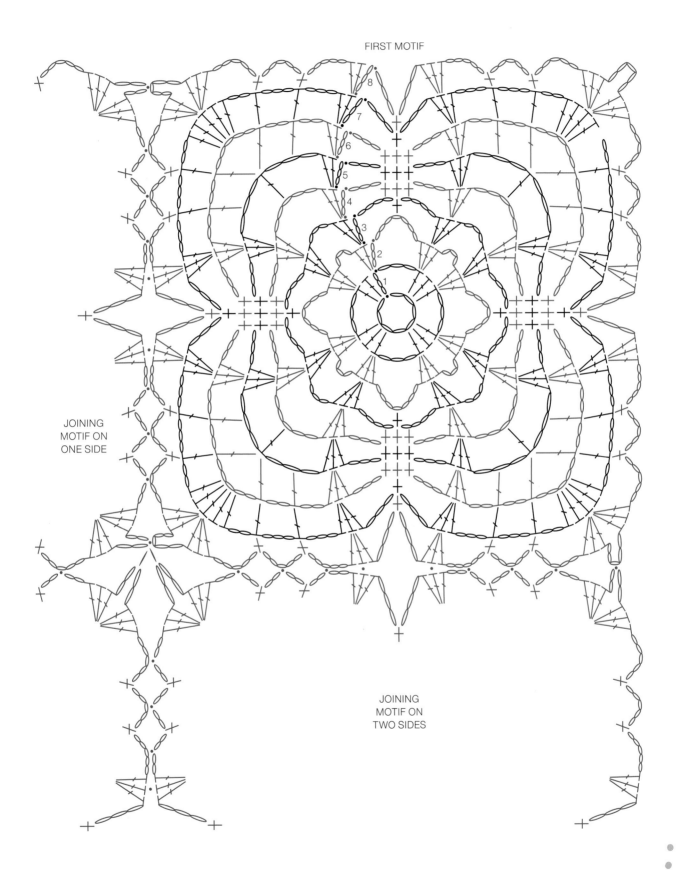

FIRST MOTIF

8
7
6
5
4
3
2
1

JOINING
MOTIF ON
ONE SIDE

JOINING
MOTIF ON
TWO SIDES

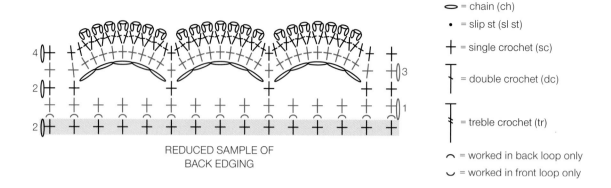

REDUCED SAMPLE OF
BACK EDGING

ch-4 sp, ch 3, sk the next dc**, 3 dc in the next dc;
rep from * around, ending last rep at **, join with
a sl st in top of beg ch-3 sp.

Rnd 5: Sl st in the next dc, ch 3, 2 dc in same st,
*ch 3, dc in the next ch-4 sp, ch 3, sk the next 2 dc,
3 dc in the next dc, sk the next dc, ch 3, sc in each
of the next 3 sc, ch 3, sk the next dc**, 3 dc in the
next dc; rep from * around, ending last rep at **,
join with a sl st in top of beg ch-3 sp.

Rnd 6: Sl st in the next dc, ch 3, 2 dc in same st,
*ch , dc in the next ch-3 sp, ch 2, (dc, ch 5, dc) in
the next dc, ch 2, dc in the next ch-3 sp, ch 2, sk
next dc, 3 dc in the next dc, ch 3, sc in each of the
next 3 sc, ch 3, sk the next dc**, 3 dc in the next dc;
rep from * around, ending last rep at **, join with
a sl st in top of beg ch-3 sp.

Rnd 7: Sl st in next dc, ch 3, 2 dc in same st, *[ch
3, dc in the next dc] twice, ch 2, 5 dc in ch-5 sp, ch
2, [dc in the next dc, ch 3] twice, sk the next dc**,
3 dc in the next dc; rep from * around, ending last
rep at **, join with a sl st in top of beg ch-3 sp.

Rnd 8: Sl st in the next dc, ch 3, 2 dc in same st, *ch
5, sk the next dc, (sc, ch 5) in each of the next 2 dc,
sk the next 2 dc, (3 dc, ch 5, 3 dc) in the next dc, ch
5, sk the next ch-2 sp, (sc, ch 5) in each of the next
2 dc, sk the next dc, 3 dc in the next dc, ch 3. Sc in
the next sc, ch 3, sk the next dc**, 3 dc in the next
dc; rep from * around, ending last rep at **, join
with a sl st in top of beg ch-3 sp. Fasten off.

Make and join 31 more Motifs the same as the
First Motif, joining each to the previous Motif(s)
while completing the last rnd, joining in a rectan-
gle 4" (10 cm) wide by 8" (20.5 cm) long as follows.

SECOND AND SUCCESSIVE MOTIFS (JOINED ON ONE SIDE)

Work same as First Motif through Rnd 7.

Rnd 8: Sl st in the next dc, ch 3, 2 dc in same st, *ch
5, sk the next dc, (sc, ch 5) in each of the next 2 dc,
sk the next 2 dc, (3 dc, ch 5, 3 dc) in the next dc, ch
5, sk the next ch-2 sp, (sc, ch 5) in each of the next
2 dc, sk the next dc, 3 dc in the next dc; rep from
* twice, ch 5, sk the next dc, (sc, ch 5) in each of
the next 2 dc, sk the next 2 dc, (3 dc, ch 2, sl st in
corner ch-5 sp of previous Motif, ch 2, 3 dc) in the
next dc, ch 2, sl st in the next ch-5 sp of previous
Motif, ch 2, sk next ch-2 sp, (sc, ch 2, sl st in the
next ch-5 sp of previous Motif, ch 2) in each of the
next 2 dc, sk the next dc, 2 dc in the next dc, sl st
in corresponding dc on previous Motif, dc in the
next dc of current Motif, ch 3, sc in the next sc, ch
2, sk the next dc, 2 dc in the next dc, sl st in cor-
responding dc on previous Motif, dc in the next dc
of current Motif, ch 2, sl st in the next ch-5 sp of
previous Motif, ch 2, sc) in each of the next 2 dc,
ch 2, sl st in the next ch-5 sp of previous Motif, ch
2, sk the next 2 dc, (3 dc, ch 2, sl st in corner ch-5
sp of previous Motif, ch 2, 3 dc) in the next dc, ch
5, sk the next ch-2 sp, (sc, ch 5) in each of the next
2 dc, sk the next dc, join with a sl st in top of beg
ch-3 sp. Fasten off.

SUCCESSIVE MOTIFS (JOINED ON TWO SIDES)

Work same as First Motif through Rnd 7.

Rnd 8: Sl st in the next dc, ch 3, 2 dc in same st,
*ch 5, sk the next dc, (sc, ch 5) in each of the next 2
dc, sk the next 2 dc, (3 dc, ch 5, 3 dc) in the next dc,
ch 5, sk the next ch-2 sp, (sc, ch 5) in each of the

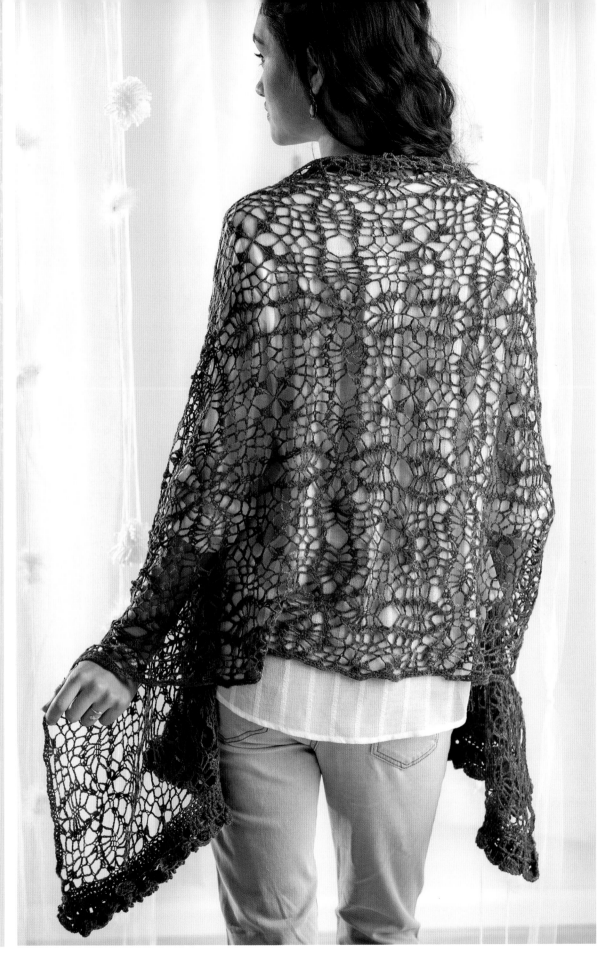

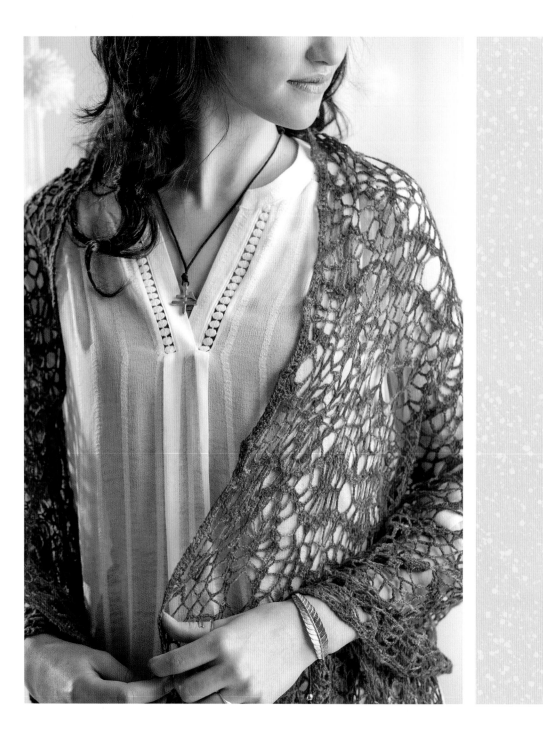

next 2 dc, sk the next dc, 3 dc in the next dc; rep from * once, ch 5, sk the next dc, (sc, ch 5) in each of the next 2 dc, sk the next 2 dc, (3 dc, ch 2, sl st in corner ch-5 sp of previous Motif, ch 2, 3 dc) in the next dc, **ch 2, sl st in the next ch-5 sp of previous Motif, ch 2, sk the next ch-2 sp, (sc, ch 2, sl st in the next ch-5 sp of previous Motif, ch 2) in each of the next 2 dc, sk the next dc, 2 dc in the next dc, sl st in corresponding dc on previous Motif, dc in the next dc of current Motif, ch 3, sc in the next sc, ch 2, sk the next dc, 2 dc in the next dc, sl st in corresponding dc on previous Motif, dc in the next dc of current Motif, ch 2, sl st in the next ch-5 sp of previous Motif, ch 2, sc) in each of the next 2 dc, ch 2, sl st in the next ch-5 sp of previous Motif, ch 2, sk the next 2 dc, (3 dc, ch 2, sl st in corner ch-5

sp of previous Motif, ch 2, 3 dc) in the next dc; rep from ** once, ch 5, sk the next ch-2 sp, (sc, ch 5) in each of the next 2 dc, sk the next dc, join with a sl st in top of beg ch-3 sp. Fasten off.

EDGING

Rnd 1: With RS facing, join yarn in the corner ch-5 sp on the right-hand side of one short edge, ch 1, sc evenly around the entire piece, working 135 sc on short edge and 324 on each long edge, join with a sl st in the first sc.

FRONT RUFFLE BORDER

Row 1: (RS) Ch 1, sc in each sc across to the next corner, working 135 sc, turn.

Row 2: Ch 1, sc in each sc across, turn.

Rnd 3: (RS) Ch 5 (counts as tr, ch 1), *sk the next 2 sc, tr in the front loop of each of the next 3 sc, ch 1; rep from * across to the last sc on short side, tr in last sc, turn—34 ch-1 sps.

Rnd 4: Ch 1, sc in first tr, sc in the next ch-1 sp, (ch 5, sc) in each ch-1 sp across to the last ch-1 sp, sc in the 4th ch of tch, turn—33 ch-5 sps.

Rnd 5: Ch 1, sc in first 2 sc, *8 tr in the next ch-5 sp, sc in the next sc; rep from * across, sc in the last sc—33 shells. Fasten off.

BACK RUFFLE BORDER

Row 1: (RS) With RS facing, join yarn with a sl st in the rem back loop of the first st in Row 2 of the Front Ruffle Border, ch 1, sc in the rem back loop of each sc across, turn.

Row 2: Ch 1, sc in each of the first 2 sc, *ch 5, sk the next 3 sc, sc in the next sc; rep from * across, sc in the last sc, turn—33 ch-5 sps.

Row 3: Ch 1, sc in each of the first 2 sc, *9 sc in the next ch-5 sp, sc in the next sc; rep from * across, sc in the last sc, turn.

Row 4: Ch 1, sc in each of the first 3 sc, *(sc, ch 3, sc) in each of the next 7 sc, sc in each of the next 3 sc; rep from * across. Fasten off.

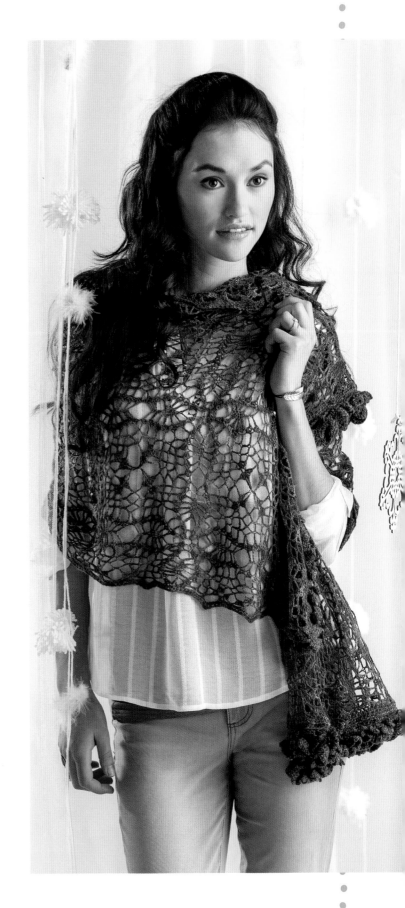

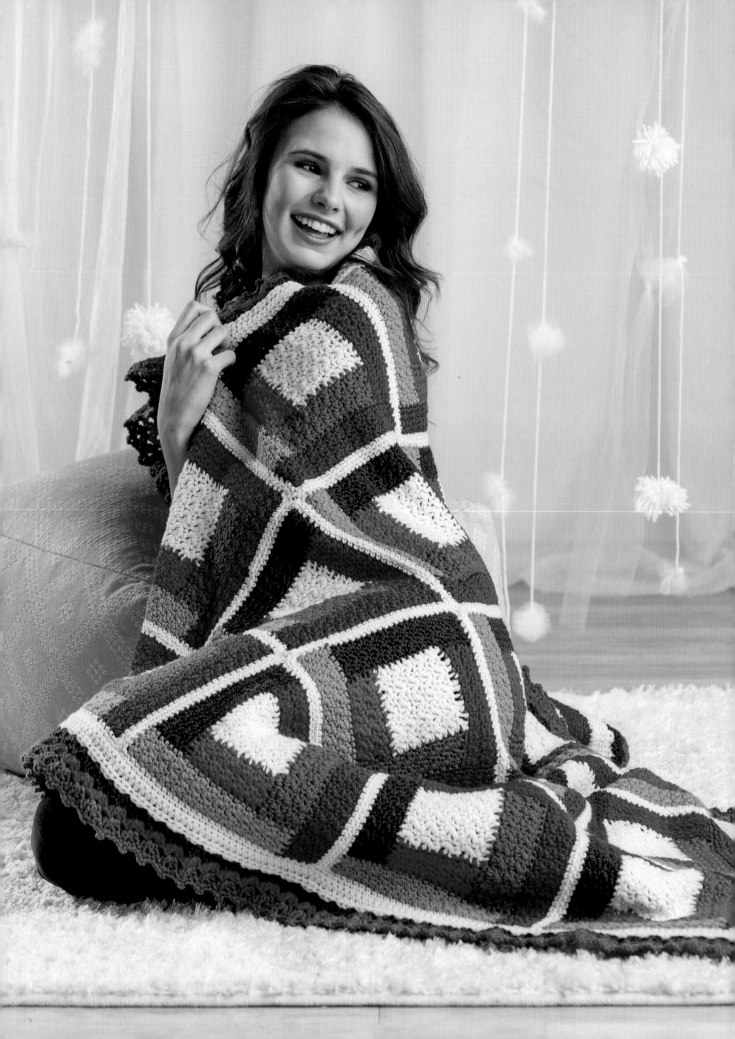

LOG CABIN
BLANKET

A log cabin quilt is a quintessential design most quilters make and one that is easily translated into crochet. I chose to make this blanket in my favorite crochet stitch and use really bright colors to make it more modern! The yarn used is 100 percent wool, so this is a blanket that will keep you warm on that cold winter night.

FINISHED MEASUREMENTS
About 51½" (131 cm) by 51½" (131 cm) after blocking.

YARN
Worsted weight (#4 Medium).

Shown here: Brown Sheep Nature Spun Worsted (100% wool, 245 yd [224 m]/3½ oz [100 g]): #730W Natural (A), #108W Cherry Delight (B), #120W Cresting Waves (C), #105W Bougainvillea (D), #137W Cobalt Blue (E), #109W Spring Green (F), and #207W Alpine Violet (G), 1 skein each.

HOOK
Size I-9/5.5 mm hook. *Adjust hook size if necessary to obtain the correct gauge.*

NOTIONS
Yarn needle.

GAUGE
11 sts and 8 rows = 3½" (9 cm) in block pattern. 1 block = 9" (23 cm) by 9" (23 cm) in the pattern after blocking.

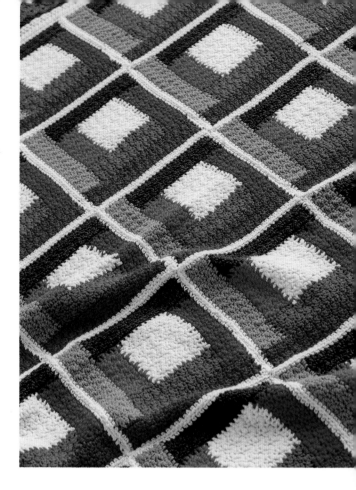

NOTES

❋ Change colors on the last stitch of row or round when indicated.

STITCH GUIDE

Beginning shell (beg shell): (Dc, ch 1, 2 dc) in same st or sp.

Shell: (2 dc, ch 1, 2 dc) in same st or sp.

Corner shell: (3 dc, ch 1, 3 dc) in same sp.

V-stitch (V-st): (Dc, ch 1, dc) in same sp.

BLANKET

CENTER SQUARE

With A, ch 12.

Row 1: (RS) Sc in 2nd ch from hook, *dc in the next ch, sc in the next ch; rep from * across, turn—11 sts.

Row 2: Ch 2 (does not count as a st here and throughout), dc in the first sc, *sc in the next dc, dc in the next sc; rep from * across, turn.

Row 3: (RS) Ch 1, sc in the first dc, *dc in the next sc, sc in the next dc; rep from * across, turn.

Rows 4–9: Rep Rows 2–3 three times, changing to B on the last stitch of the last row.

FIRST RECTANGLE

Row 1: (RS) Rotate the block 90 degrees to the right, ch 1; with RS still facing and working across the side edge of the Center Square, work 13 sc evenly spaced across, turn.

Row 2: (WS) Ch 2, dc in the first sc, *sc in the next sc, dc in the next sc; rep from * across, turn.

Row 3: (RS) Ch 1, sc in the first dc, *dc in the next sc, sc in the next dc; rep from * across, turn.

Rows 4–5: Rep Rows 2–3 once, changing to C on the last stitch of the last row.

SECOND RECTANGLE

Row 1: (RS) Rotate the block 90 degrees to the right, ch 1; with RS still facing and working across the side edge of the Block, work 18 sc evenly spaced across, turn.

Row 2: (WS) Ch 2, dc in the first sc, *sc in the next sc, dc in the next sc; rep from * across to the last sc, sc in the last sc, turn.

Row 3: (RS) Ch 2, dc in the first sc, *sc in the next dc, dc in the next sc; rep from * across to the last st, sc in the last dc, turn.

Rows 4–5: Rep Rows 2–3 once, changing to D on the last stitch of the last row.

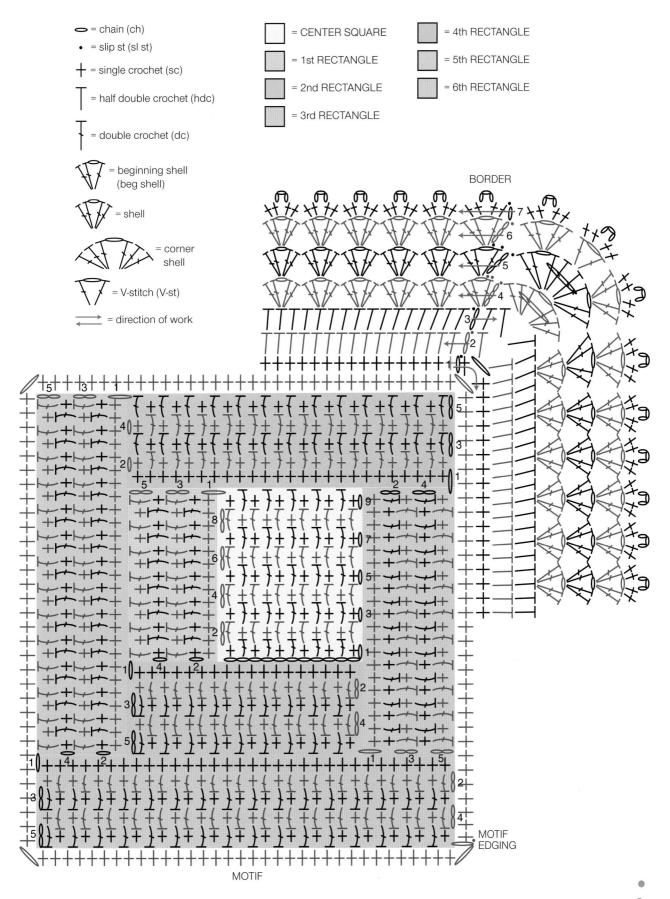

= chain (ch)

• = slip st (sl st)

+ = single crochet (sc)

T = half double crochet (hdc)

= double crochet (dc)

= beginning shell
(beg shell)

= shell

= corner shell

= V-stitch (V-st)

= direction of work

= CENTER SQUARE

= 1st RECTANGLE

= 2nd RECTANGLE

= 3rd RECTANGLE

= 4th RECTANGLE

= 5th RECTANGLE

= 6th RECTANGLE

BORDER

MOTIF

MOTIF EDGING

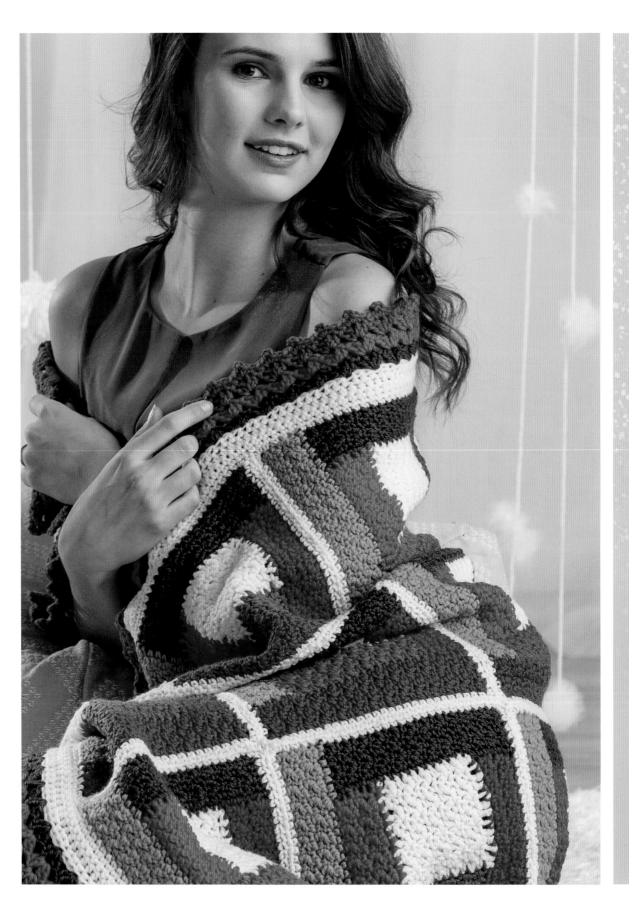

THIRD RECTANGLE

Row 1: (RS) Rotate the block 90 degrees to the right, ch 1; with RS still facing and working across the side edge of the block, work 20 sc evenly spaced across the row, turn.

Row 2: (WS) Ch 2, dc in first sc, *sc in the next sc, dc in the next sc; rep from * across to the last sc, sc in the last sc, turn.

Row 3: (RS) Ch 2, dc in the first sc, *sc in the next dc, dc in the next sc; rep from * across to the last st, sc in the last dc, turn.

Rows 4-5: Rep Rows 2-3 once, changing to E on the last stitch of the last row.

FOURTH RECTANGLE

Row 1: (RS) Rotate the block 90 degrees to the right, ch 1; with the RS still facing and working across the side edge of the block, work 25 sc evenly spaced across the row, turn.

Row 2: (WS) Ch 2, dc in the first sc, *sc in the next sc, dc in the next sc; rep from * across, turn.

Row 3: (RS) Ch 1, sc in the first dc, *dc in the next sc, sc in the next dc; rep from * across, turn.

Rows 4-5: Rep Rows 2-3 once, changing to F on the last stitch of the last row.

FIFTH RECTANGLE

Row 1: (RS) Rotate the block 90 degrees to the right, ch 1; with the RS still facing and working across the side edge of the block, work 27 sc evenly spaced across the row, turn.

Row 2: (WS) Ch 2, dc in the first sc, *sc in the next sc, dc in the next sc; rep from * across, turn.

Row 3: (RS) Ch 1, sc in the first dc, *dc in the next sc, sc in the next dc; rep from * across, turn.

Rows 4-5: Rep Rows 2-3 once, changing to G on the last stitch of the last row.

SIXTH RECTANGLE

Row 1: (RS) Rotate the block 90 degrees to the right, ch 1; with the RS still facing and working

across the side edge of the block, work 32 sc evenly spaced across the row, turn.

Row 2: (WS) Ch 2, dc in the first sc, *sc in the next sc, dc in the next sc; rep from * across to the last sc, sc in the last sc, turn.

Row 3: (RS) Ch 2, dc in the first sc, *sc in the next sc, dc in the next sc; rep from * across to the last st, sc in the last dc, turn.

Rows 4-5: Rep Rows 2-3 once, changing to A on the last stitch of the last row.

MOTIF EDGING

Rotate the block 90 degrees to the right, ch 1; with the RS still facing and working across the side edge of the block, work 34 sc evenly spaced across the row to the next corner, ch 1, rotate the block 90 degrees to the right, work 32 sc evenly spaced across the row to the next corner, ch 1; rep from * once, join with a sl st in first sc. Fasten off.

ASSEMBLY

Weave in the ends. Wash and block all of the blocks to size.

With all of the blocks facing the same direction and using a mattress stitch, sew the blocks together in a square 5 wide by 5 deep. Block the strips to size.

BORDER

With 34-sc edges at the top and bottom and 32-sc edges on the sides, join A with a sl st in the top right-hand corner of the blanket, *ch 1; with RS facing and working across the long edge of the blanket, work 230 sc evenly spaced across the row to the next corner, ch 1, rotate the blanket 90 degrees to the right; working across the short edge of the blanket, work 209 sc evenly spaced across the row to the next corner, ch 1; rep from * once, ch 1, join with a sl st in the first sc, turn—878 sc.

Rnd 1: (WS) Ch 1, *(sc, ch 1, sc) in the next ch-1 sp, sc in each sc across to the next ch-1 sp; rep from * around, join with a sl st to the first sc, turn—886 sc.

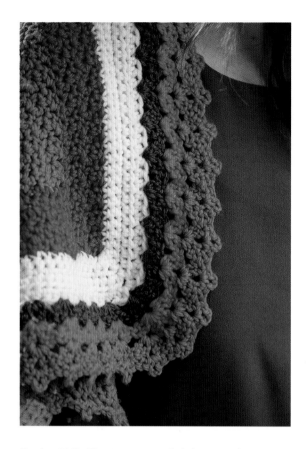

Rnd 2: (RS) Ch 2 (counts as hdc here and throughout), *hdc in each sc across to the next ch-1 sp, (hdc, ch 1, hdc) in the next ch-1 sp; rep from * around, join with a sl st in the top of the beg ch-2 sp, turn—894 hdc.

Rnd 3: (WS) Ch 2, *(hdc, ch 1, hdc) in the next ch-1 sp, hdc in each st across to the next ch-1 sp; rep from * around, join with a sl st in the top of the beg ch-2 sp, turn—902 hdc.

Rnd 4: (RS) Ch 3 (counts as dc here and throughout), beg shell in first st, sk the next 2 sts, ** *shell in the next st, sk the next 2 sts; rep from * across to the next corner ch-1 sp, corner shell in the next corner ch-1 sp, sk the next 2 sts; rep from ** around, join with a sl st to the top of the beg ch-3 sp. Fasten off.

Rnd 5: With the RS facing, join D with a sl st in the first ch-1 sp, ch 3, beg shell in the same sp, *shell in each ch-1 space to the next corner shell, sk the next 5 dc,(shell, ch 1, shell) in the corner ch-1 sp; rep from * around, join with a sl st in the top of the beg ch-3 sp. Fasten off.

Rnd 6: With RS facing, join E with a sl st in the first ch-1 sp, ch 3, beg shell in the same sp, *shell in each ch-1 space to the next corner shell, (dc, ch 1, dc) in corner ch-1 sp; rep from * around, shell in the next ch-1 sp, join with a sl st in the top of the beg ch-3 sp. Fasten off.

Rnd 7: Ch 1, *sk the next dc, sc in the next dc, (sc, ch 3 sc) in the next ch-1 sp, sc in the next dc**, [sk the next 2 dc, sc in the next dc, (sc, ch 3 sc) in the next ch-1 sp, sc in the next dc] across to the next corner V-st, sk the next dc, sc in the next dc, (sc, ch 3 sc) in the corner ch-1 sp, sc in the next dc; rep from * around, ending the last rep at **, sk the next dc, join with a sl st in the first sc. Fasten off.

FINISHING

Lightly steam the block edging.

Weave in the ends.

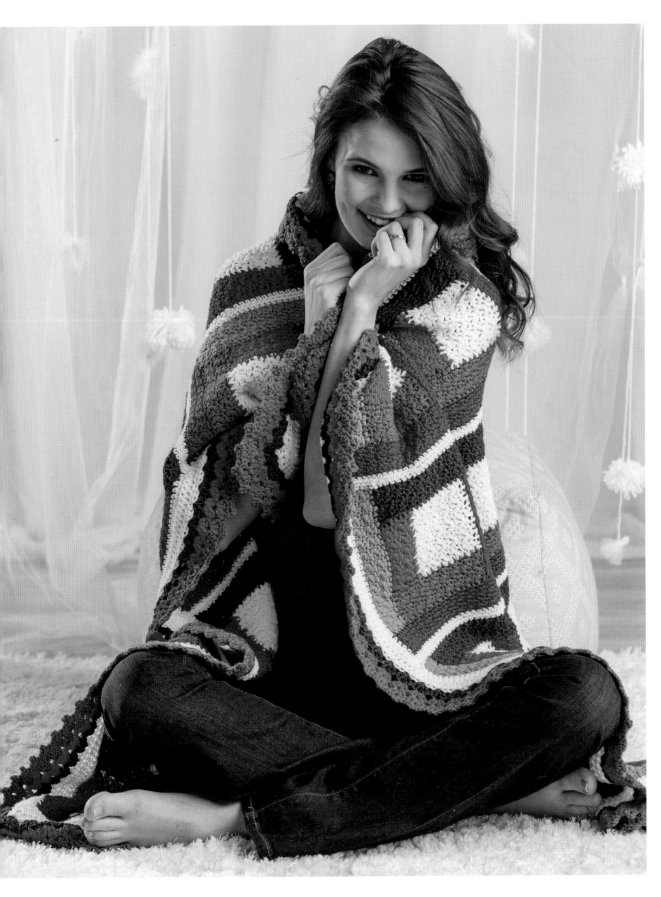

ABBREVIATIONS

BEG begin; begins; beginning

BET between

CH chain(s)

CM centimeter(s)

CONT continue(s); continuing

DC double crochet

DC2TOG double crochet 2 stitches together

DEC decrease(s); decreasing; decreased

EST established

FOLL follows; following

G gram(s)

HDC half double crochet

HDC2TOG half double crochet 2 stitches together

INC increase(s); increasing; increased loop(s)

M marker

MC main color

MM millimeter(s)

P picot

PATT pattern(s)

PM place marker

REM remain(s); remaining

REP repeat; repeating

REV SC reverse single crochet

RND round(s)

RS right side

SC single crochet

SC-BLO single crochet through back loop only

SK skip

SL ST slip(ped) stitch

SP(S) space(s)

ST(S) stitch(es)

TCH turning chain

TOG together

TR treble crochet

TR TR triple treble crochet

WS wrong side

YD(S) yard(s)

YO yarn over

***** repeat starting point

() alternate measurements and/or instructions

TECHNIQUES

FRONT POST DOUBLE CROCHET (FPDC)
Yo, insert hook from front to back to front again around the post of the next st, yo, draw yarn through st, [yo, draw yarn through 2 loops on hook] twice.

BACK POST DOUBLE CROCHET (BPDC)
Yo, insert hook from back to front to back again around the post of the next st, yo, draw yarn through st, [yo, draw yarn through 2 loops on hook] twice.

SINGLE CROCHET 2 TOGETHER (SC2TOG)
Insert the hook in the next st, yo, draw yarn through st (Figure 1), insert the hook into the next st, yo, draw yarn through st, yo, draw yarn through 3 loops on hook (Figure 2)—1 st decreased (Figure 3).

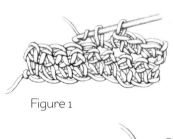

Figure 1

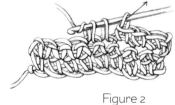

Figure 2

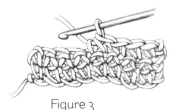

Figure 3

DOUBLE CROCHET 2 TOGETHER (DC2TOG)
[Yo, insert hook in the the next st, yo, draw yarn through st (Figure 1), yo, draw yarn through 2 loops on hook] twice (Figure 2), yo, draw the yarn through 3 loops on hook (Figure 3)—1 st decreased (Figure 4).

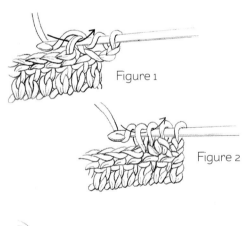

Figure 1

Figure 2

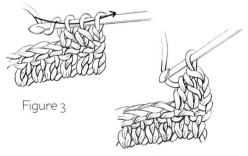

Figure 3

Figure 4

REVERSE SINGLE CROCHET (REVERSE SC)
Working from left to right, insert the hook into the next st to the right (Figure 1), yo, draw yarn through st, yo (Figure 2), draw the yarn through 2 loops on hook (Figure 3).

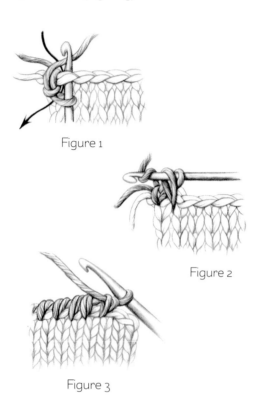

Figure 1

Figure 2

Figure 3

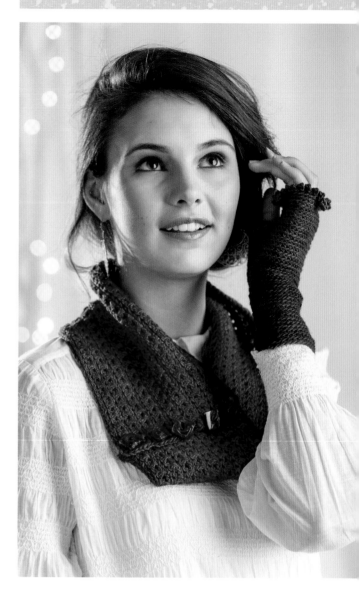

SOURCES FOR YARN

Berroco
1 Tupperware Dr., Ste. 4
N. Smithfield, RI 02896
(401) 769-1212
berroco.com

Black Bunny Fibers
blackbunnyfibers.com

Blue Sky Alpacas
PO Box 88
Cedar, MN 55011
(763) 753-5815
blueskyalpacas.com

Brown Sheep Company, Inc.
100662 County Road 16
Mitchell, NE 69357
(800) 826-9136
brownsheep.com

Cascade Yarns
cascadeyarns.com

Drew Emborsky Yarns
drewemborsky.com

Freia Fine Handpaints Yarn
6023 Christie Ave.
Emeryville, CA 94608
(800) 595-KNIT (5648)
freiafibers.com

Green Mountain Spinnery
7 Brickyard Ln.
Putney, VT 05346
(800) 321-9665
greenmountain.com

Grinning Gargoyle
etsy.com/shop/grinninggargoyle

Knitwhits
knitwhits.com

Lion Brand
135 Kero Rd.
Carlstadt, NJ 07072
(800) 258-YARN (9276)
lionbrand.com

Malabrigo
(786) 866-6187
malabrigoyarn.com

Patons
320 Livingstone Ave. S.
Box 40
Listowel, ON
Canada N4W 3H3
(855) 418-0908
yarnspirations.com/patons/

Premier Yarns
2800 Hoover Rd.
Stevens Point, WI 54481
premieryarns.com

Red Heart
PO Box 12229
Greenville, SC 29612-0229
(800) 648-1479
shopredheart.com

Twisted Fiber Art
(517) 833-9144
twistedfiberart.com

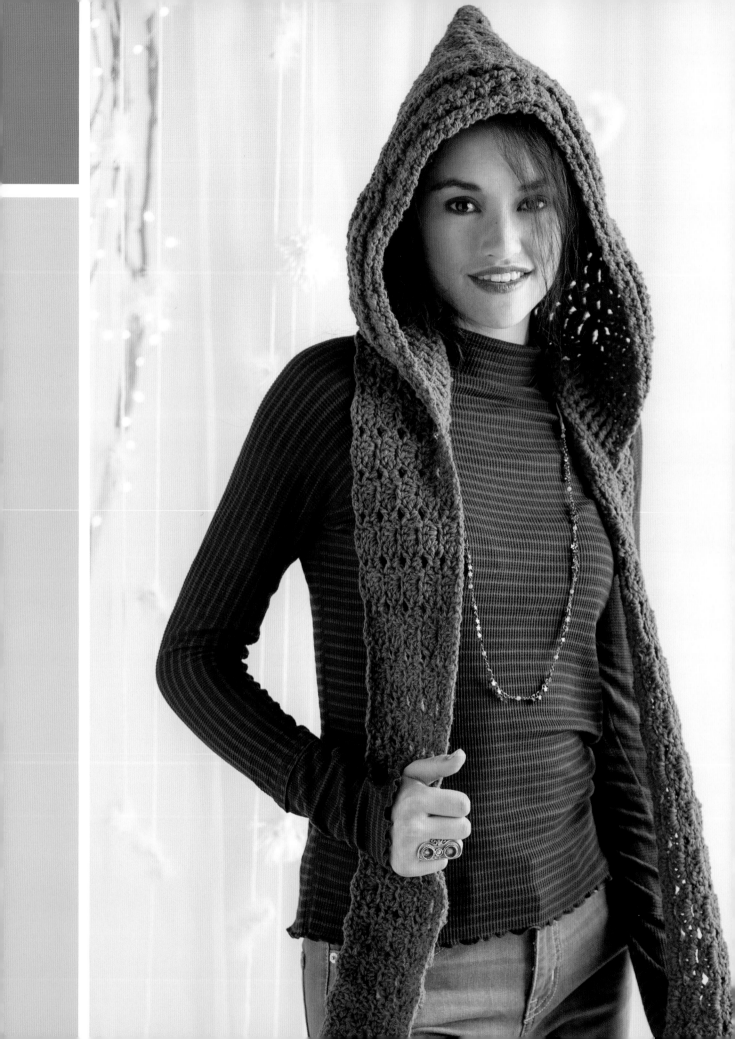

INDEX

ACQUISITIONS EDITOR Kerry Bogert
EDITOR Erica Smith
TECHNICAL EDITOR Karen Manthey
PHOTOGRAPHY Joe Hancock
STYLING Allie Liebgott
HAIR & MAKEUP Kathy MacKay
COVER & INTERIOR DESIGN Kerry Jackson

Interweave
A division of F+W Media, Inc.
4868 Innovation Dr.
Fort Collins, CO 80525
interweave.com

Manufactured in China
by RR Donnelley Shenzhen.

ISBN 978-1-63250-125-7 (pbk.)
ISBN 978-1-63250-126-4 (PDF)

10 9 8 7 6 5 4 3 2 1

This book is dedicated to my parents: To my Dad, who has shown me through his own life that faith in God, hard work, and a little luck will lead to great success and happiness; and to my Mom, who gave me a sense of style and offers me encouragement and unending love every day.

Crocheting all the pieces for this book was a lot of fun but I did have a little help along the way from Marly's Minions. Without these wonderful ladies I wouldn't be half as productive as I am. Thank you to Jenni Castaneda, Kristina Palmer, Michele Byars, Emily Furda, and Cheryl Japenga.

Thank you to everyone at Interweave, especially Kerry Bogert and Erica Smith for your hard work and perseverance on this project. I would like to give a special thanks to my tech editor, Karen Manthey, for making the patterns of this crazy designer come to life in word and chart format.

Most importantly, I would like to thank my family for their love and support: To my kids, Allura, Caden, and Josiah. Watching you three grow into faithful and loving people brings joy to my heart. I love you with all the love I have to give. And to my husband, John: your constant support, unwavering love, and belief in me is priceless. Thank you for being my partner in life!

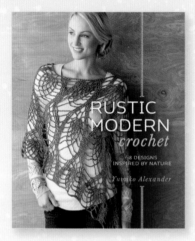
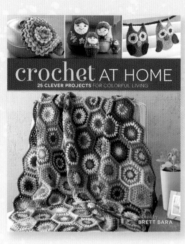
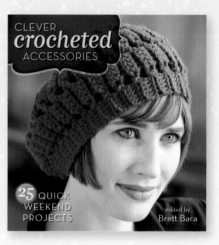